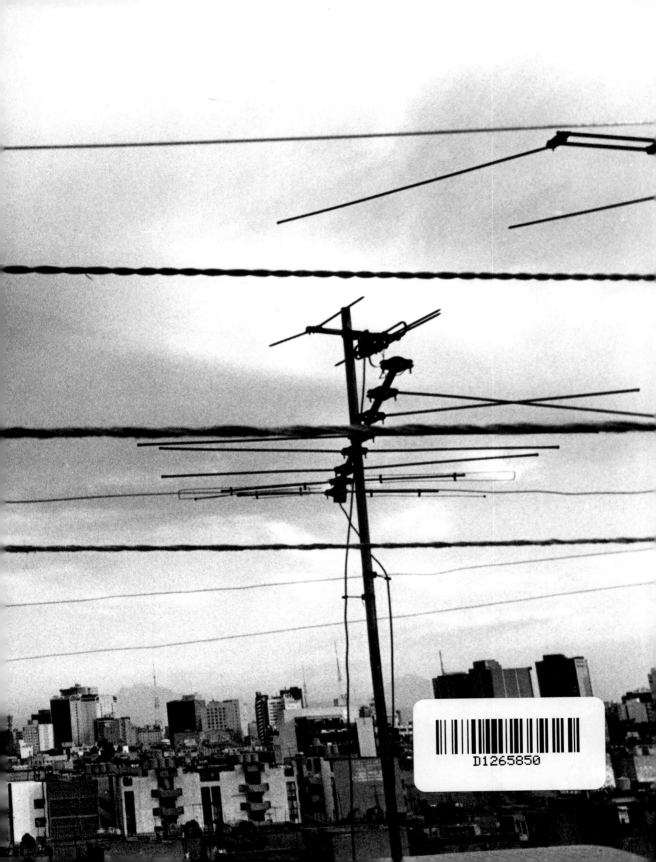

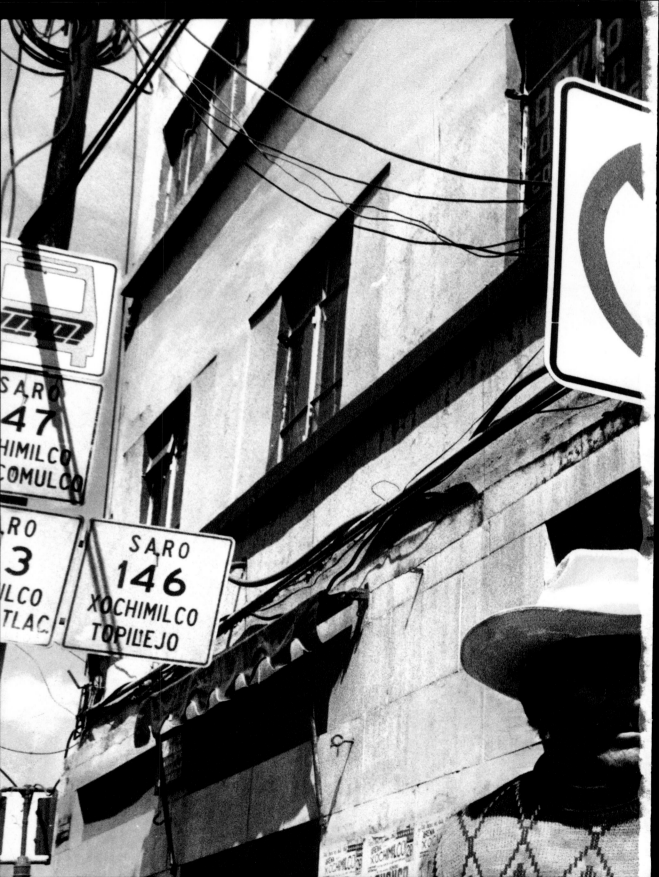

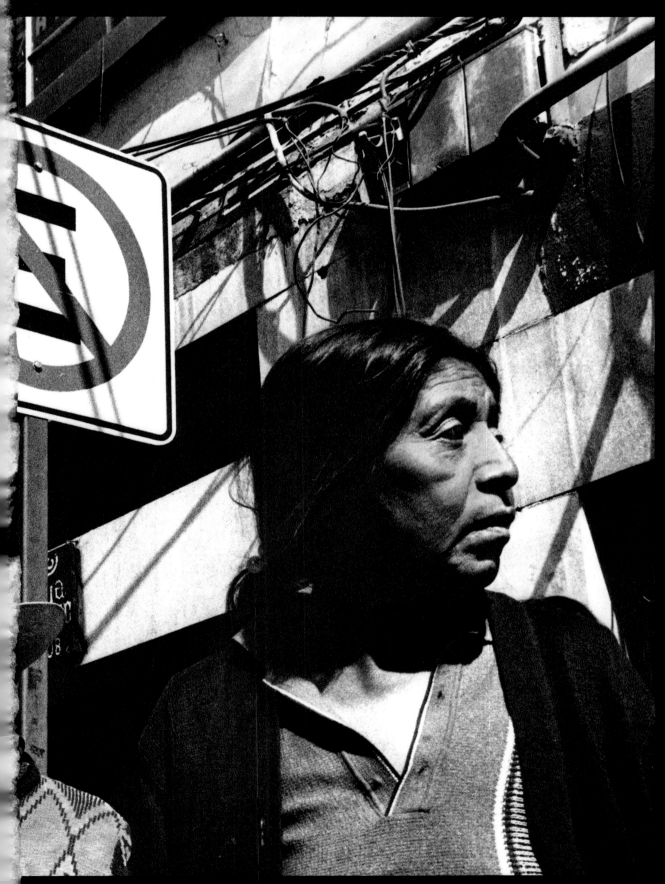

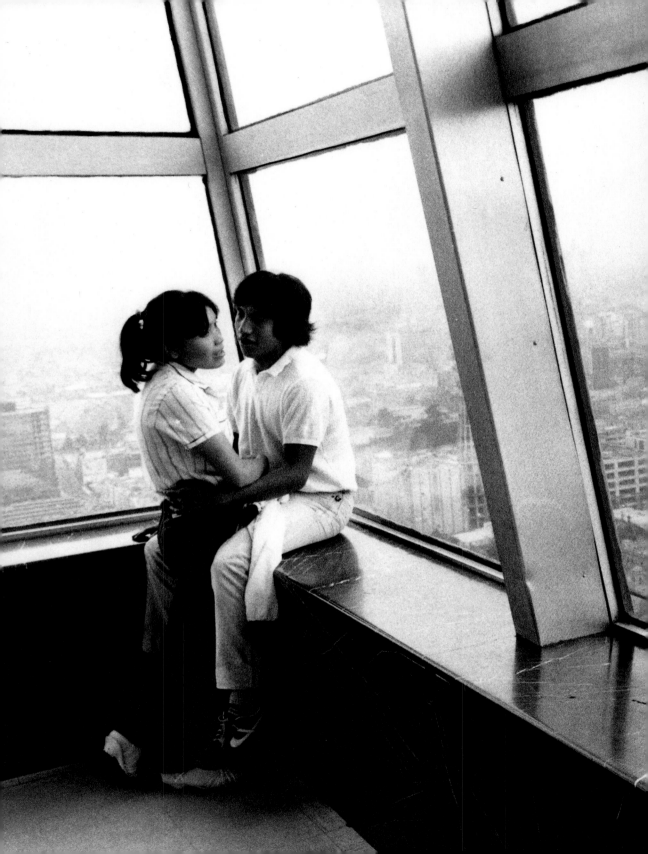

THE LAST CITY

PABLO ORTIZ MONASTERIO

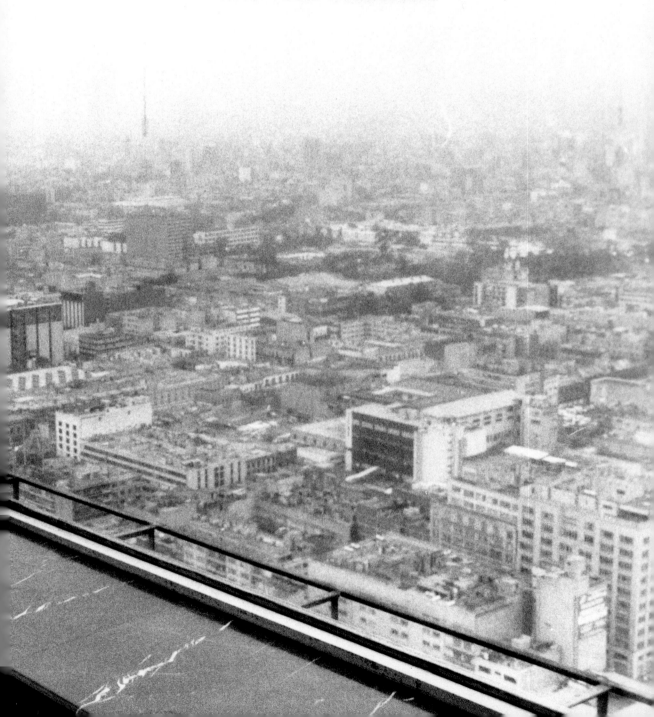

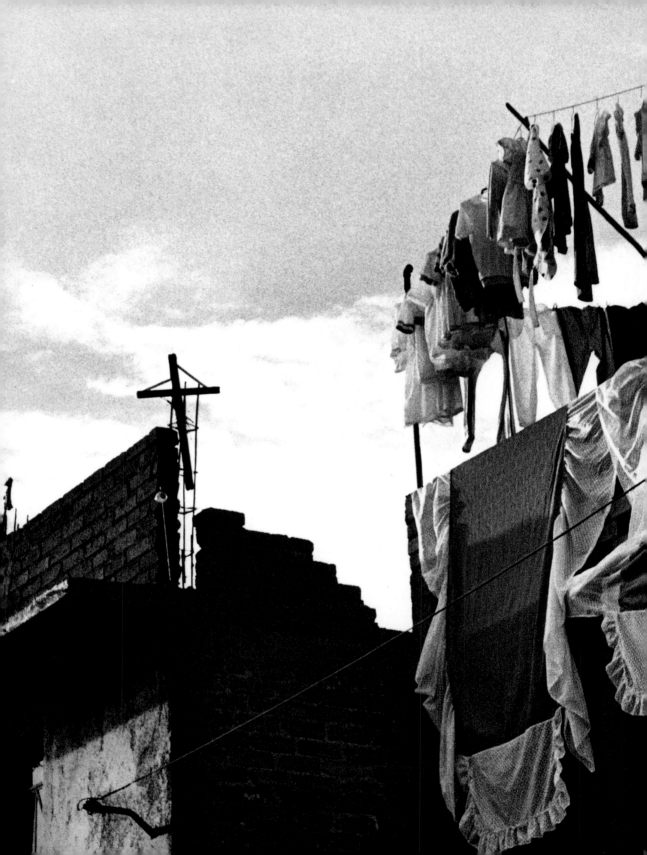

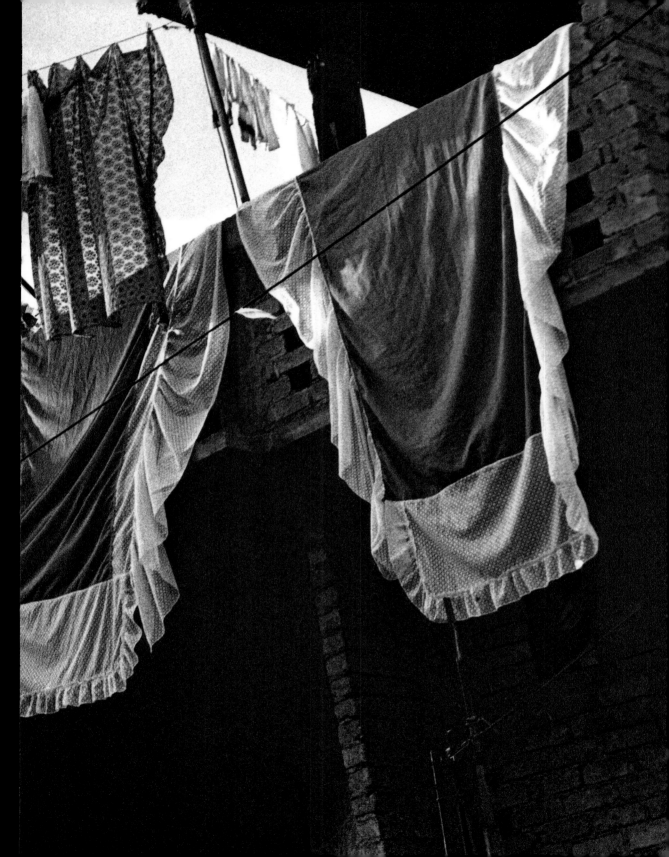

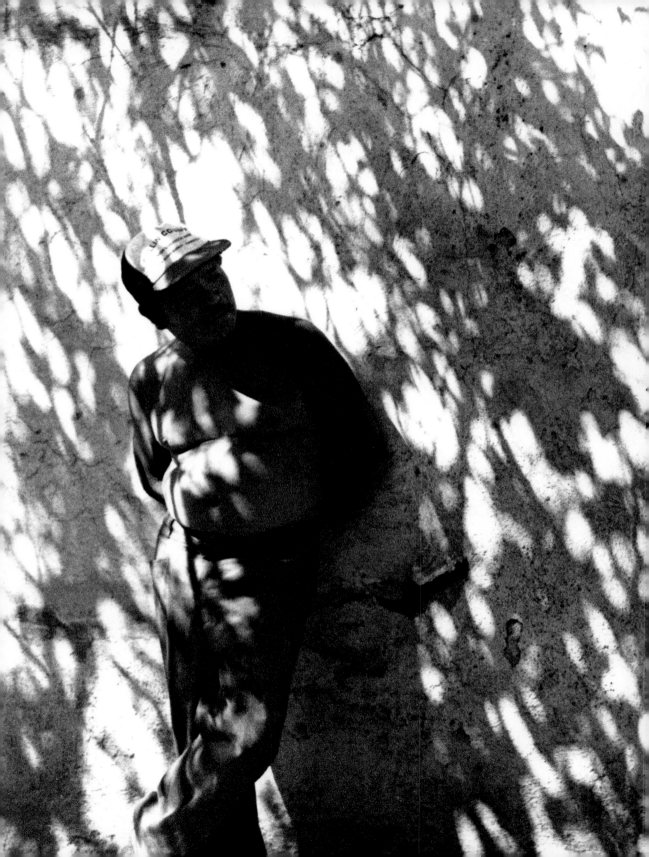

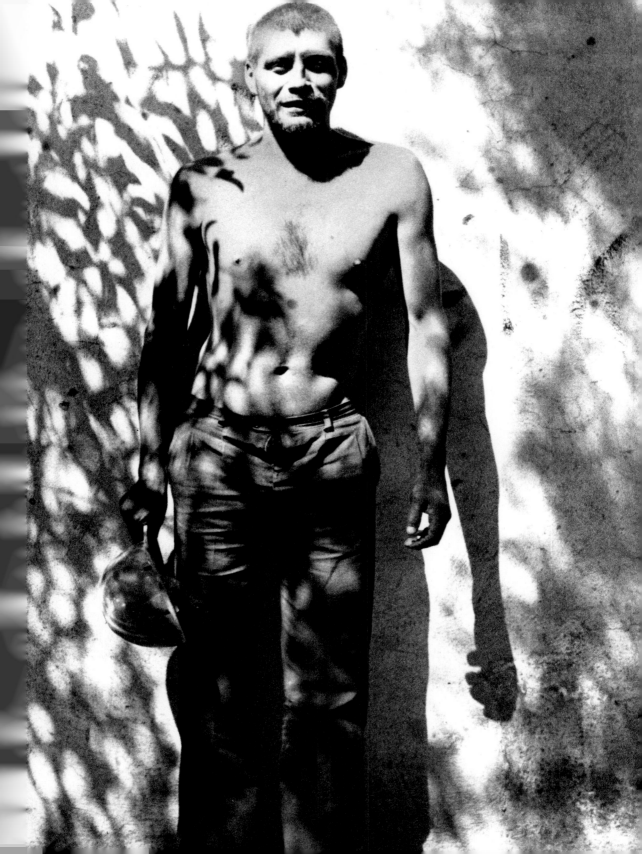

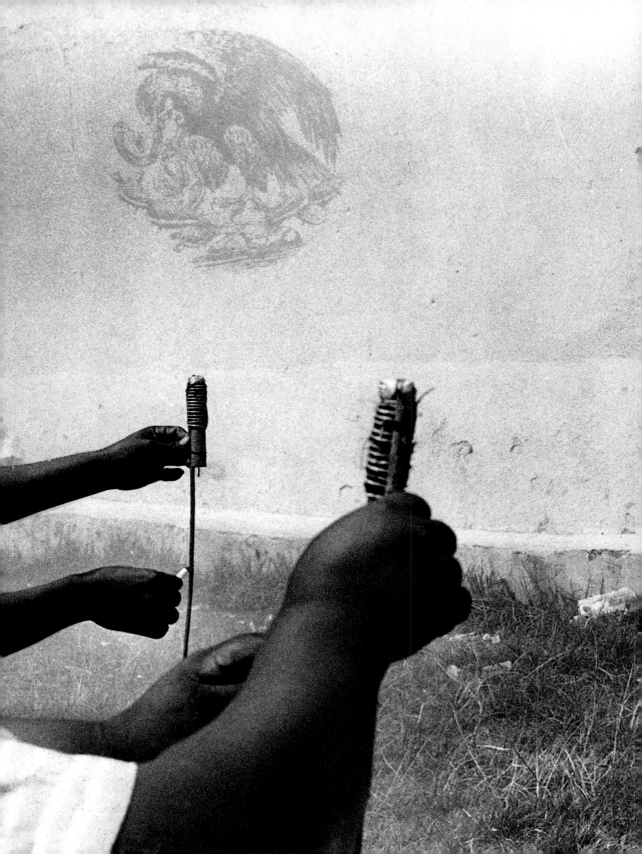

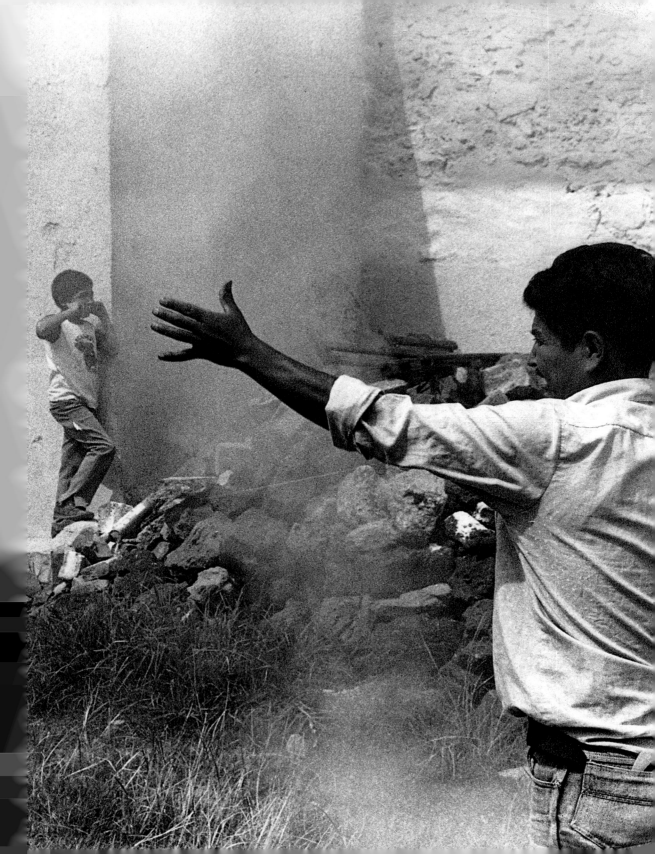

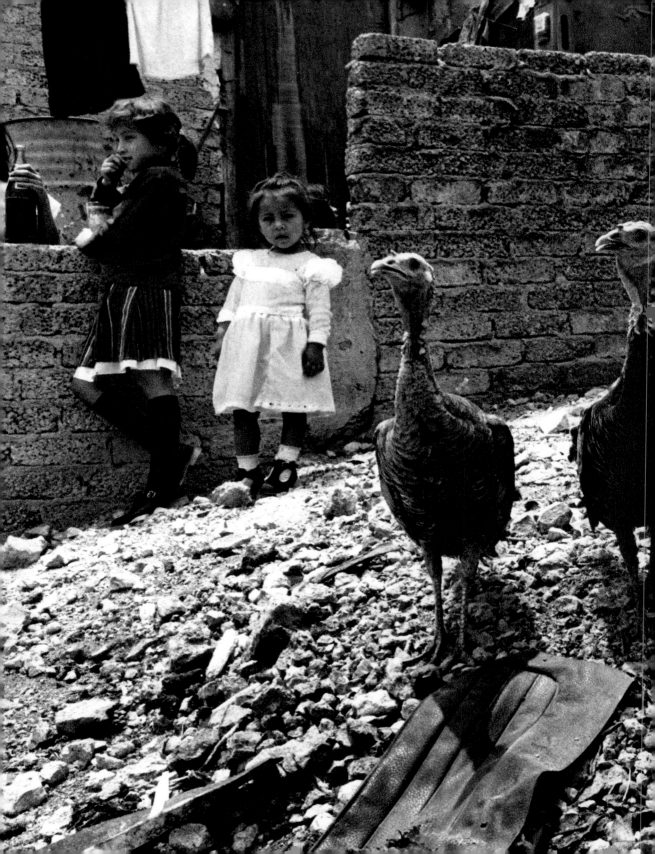

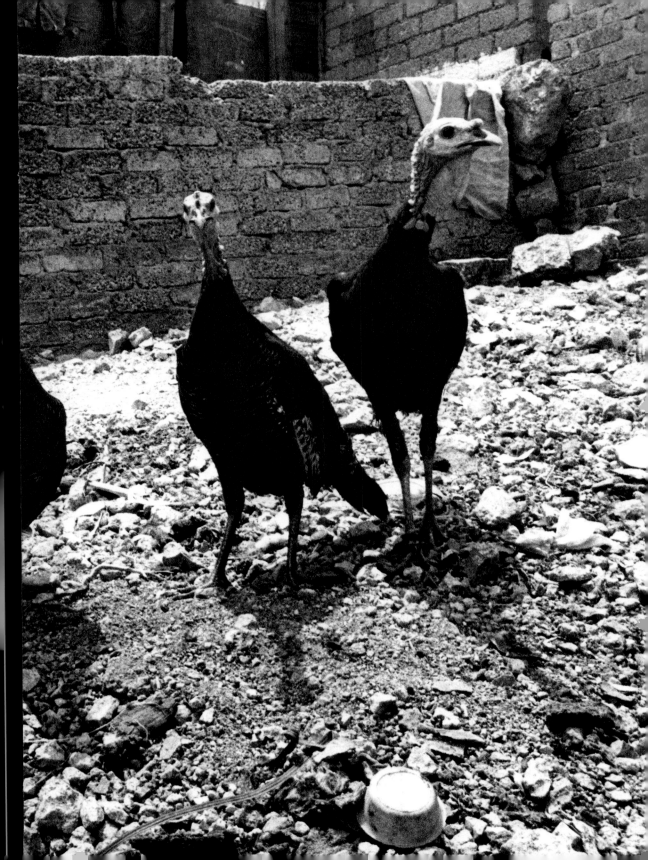

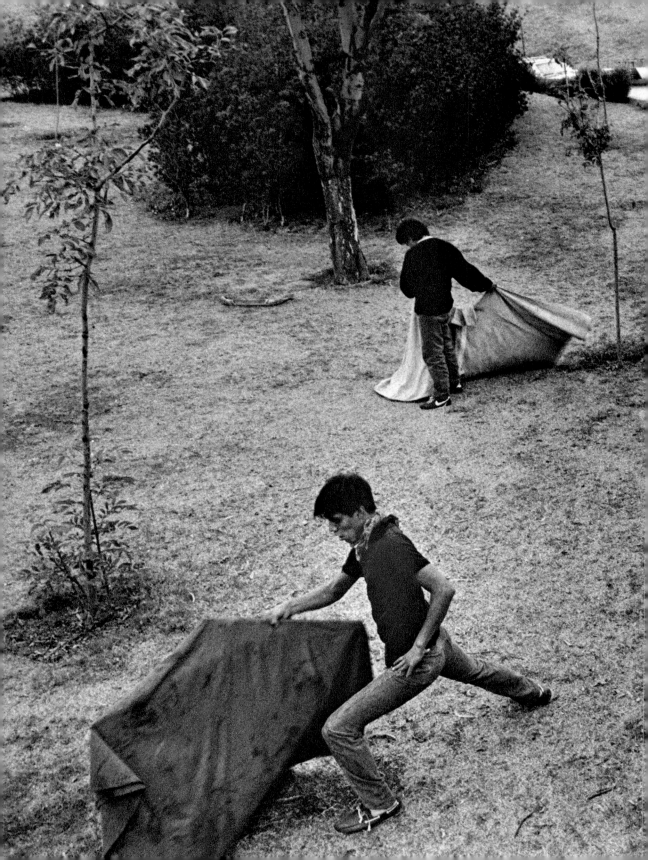

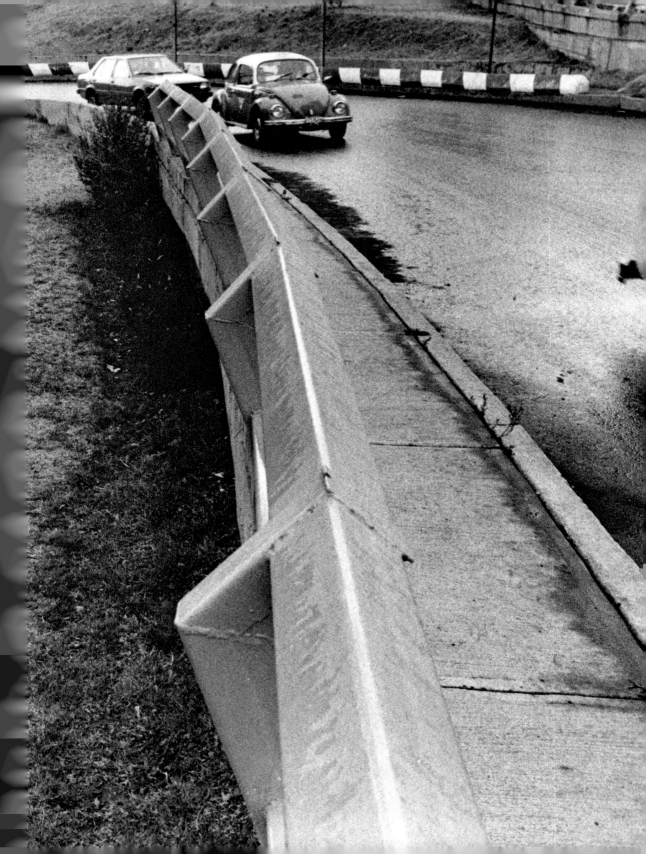

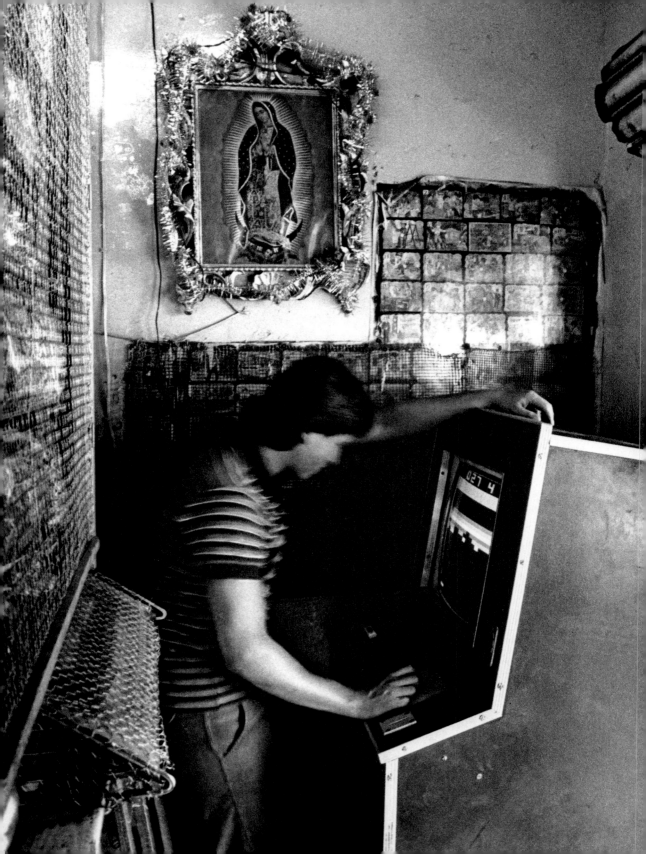

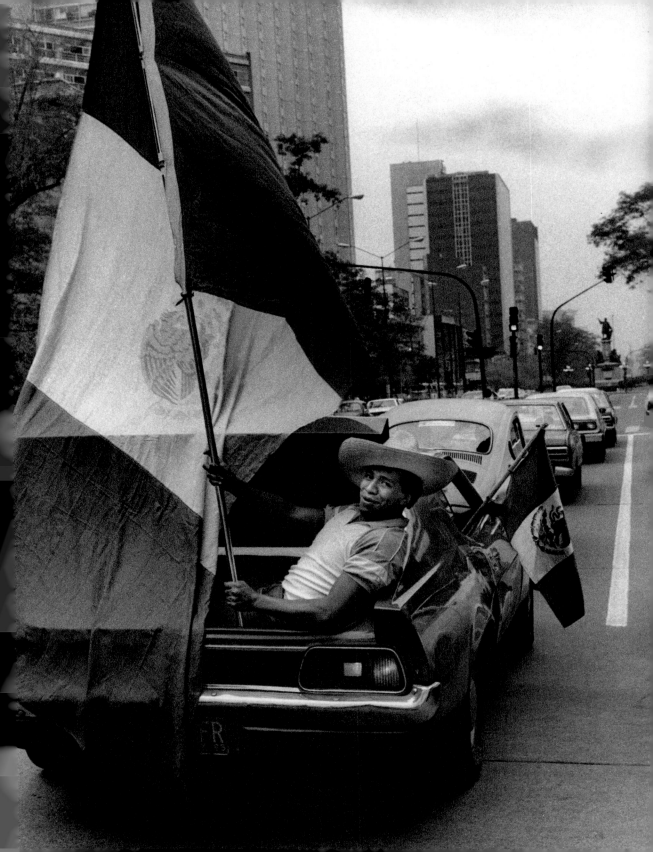

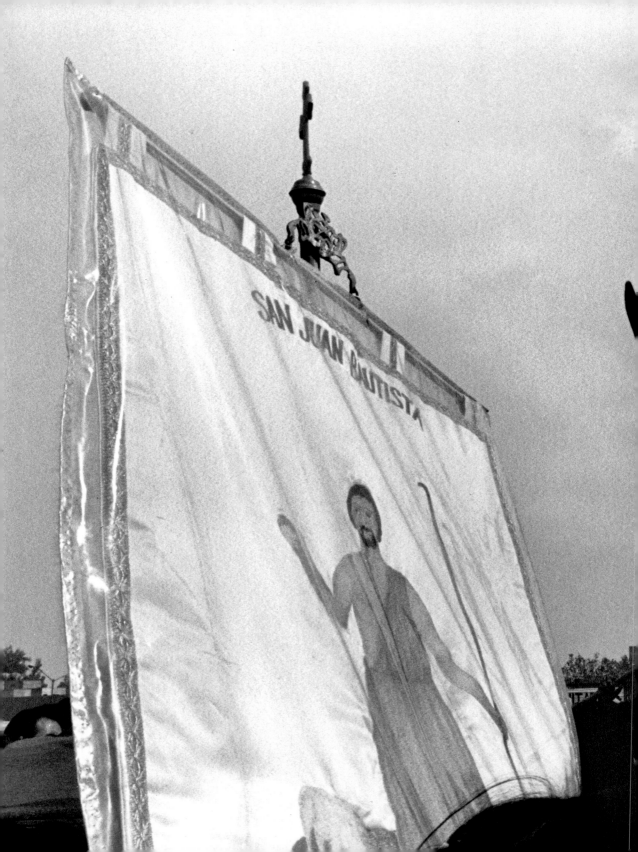

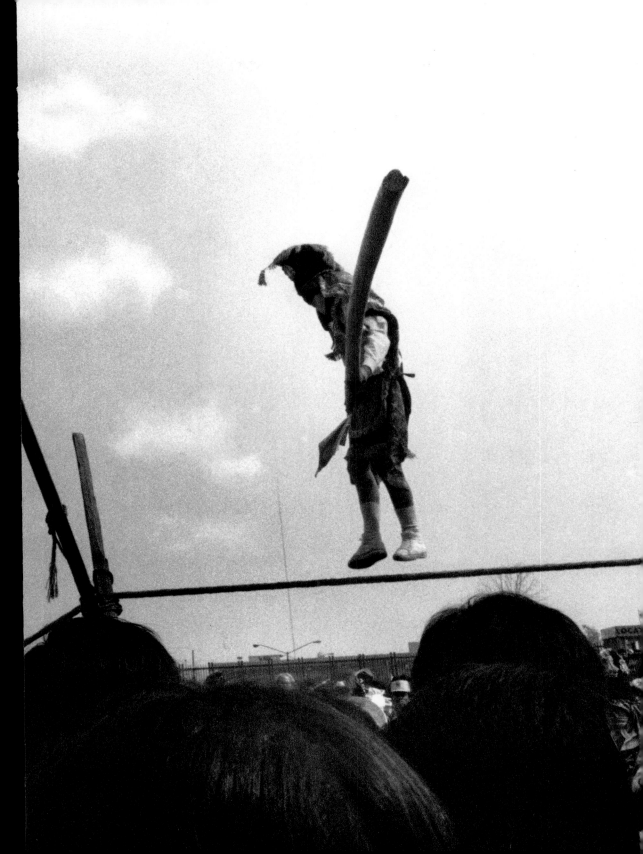

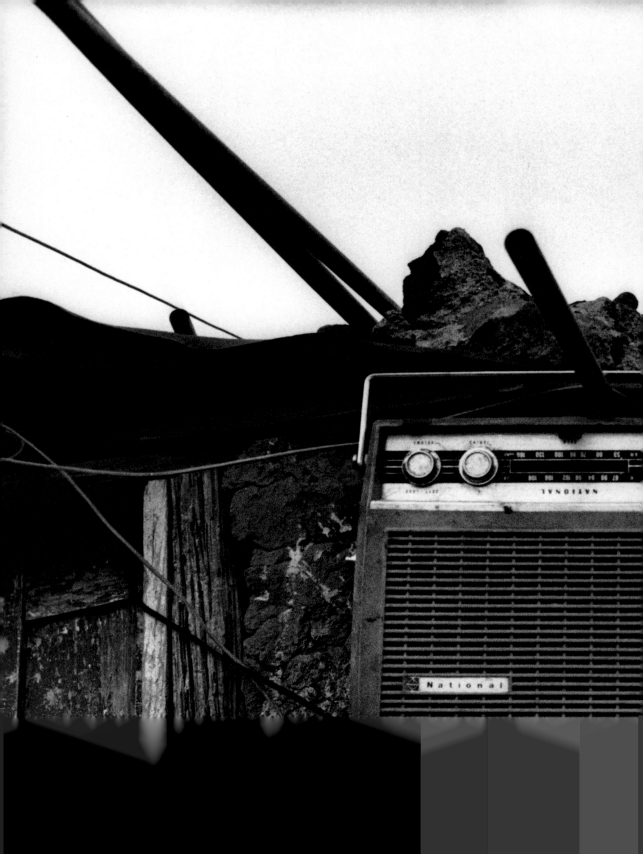

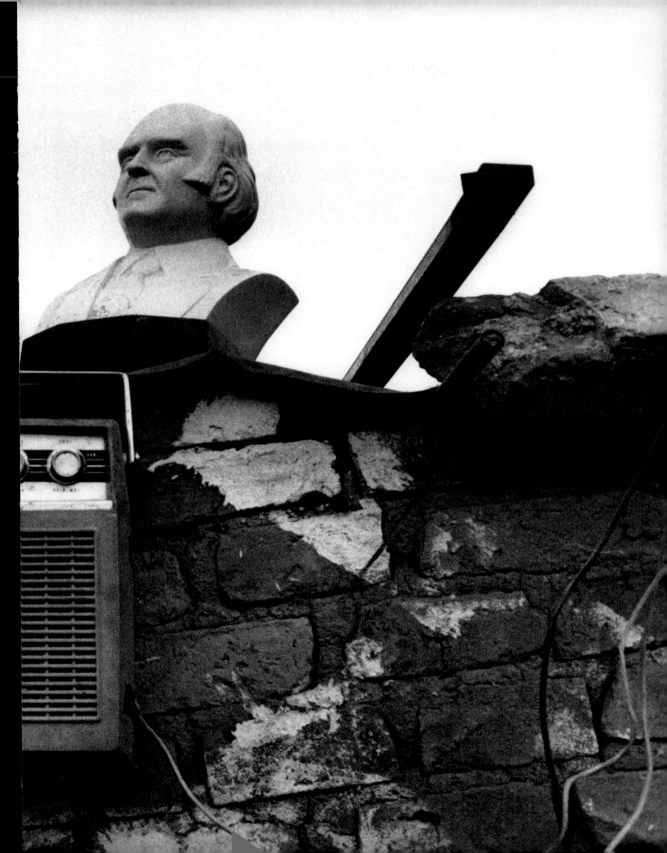

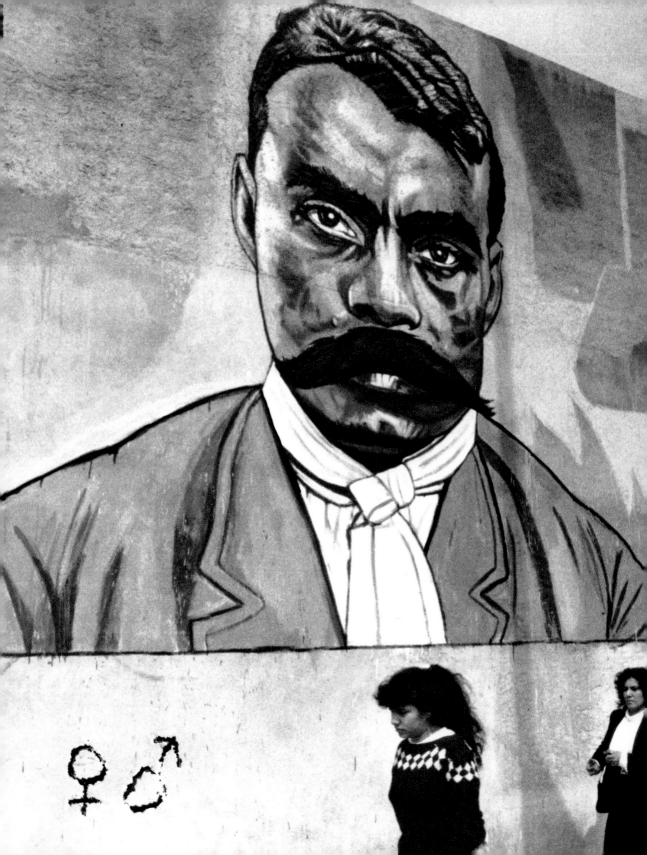

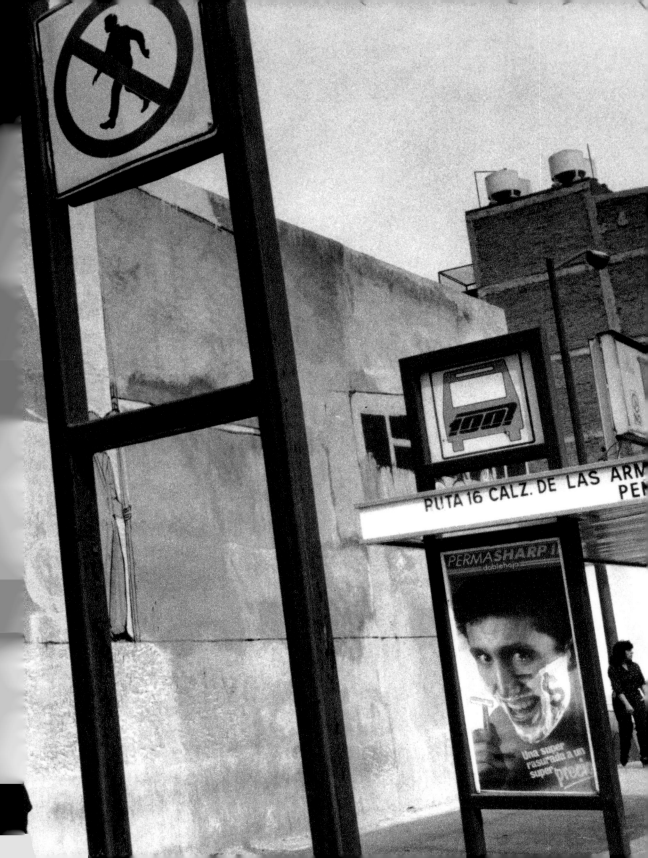

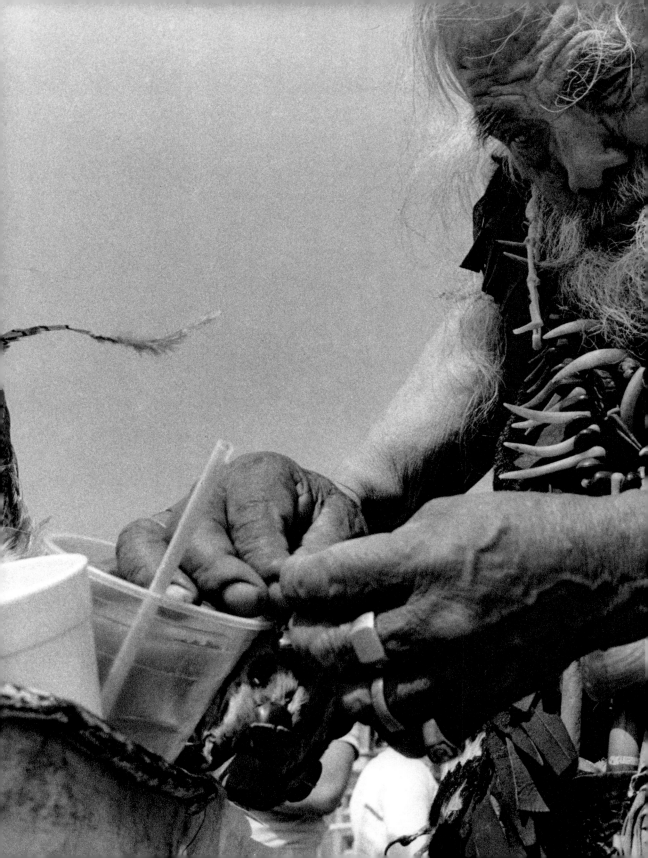

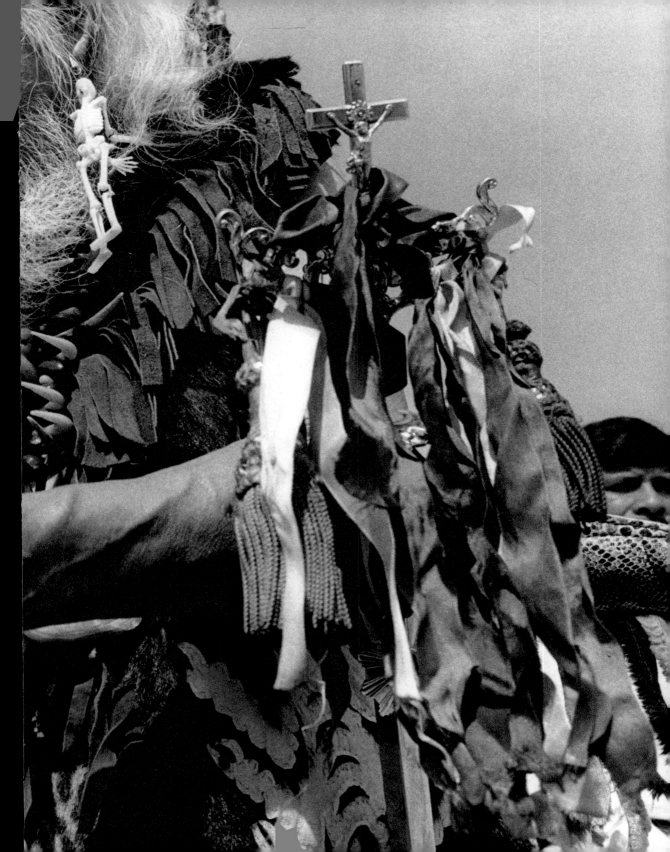

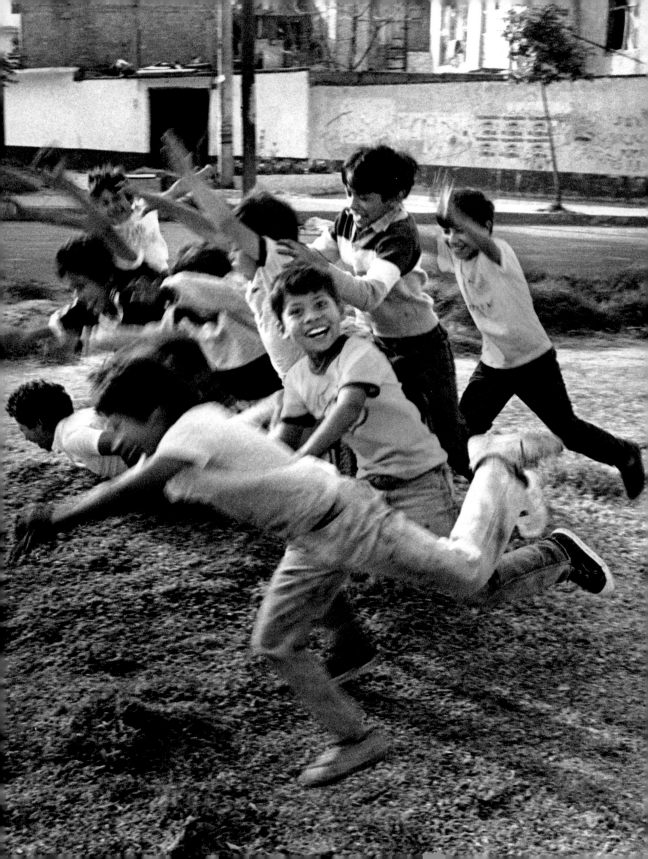

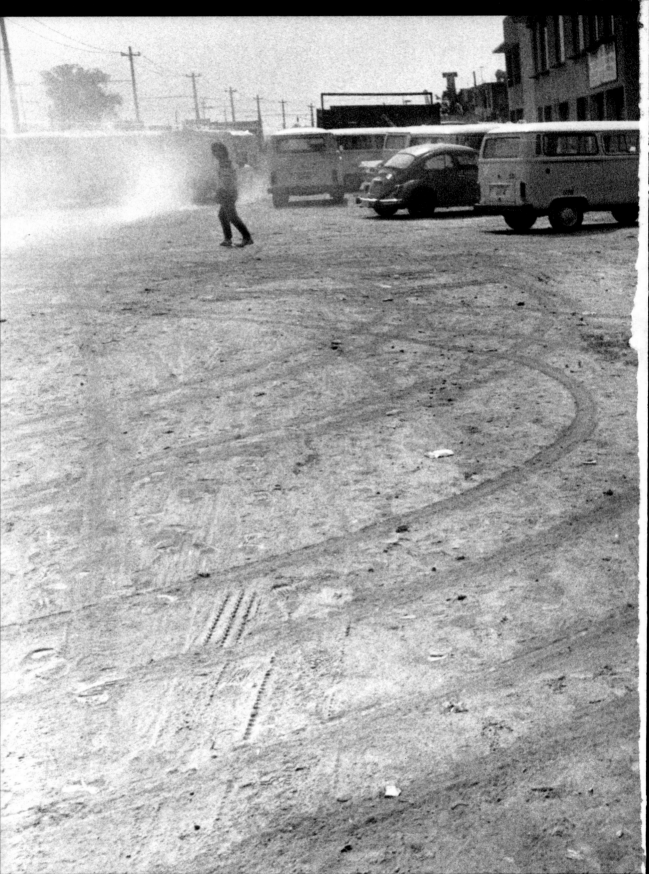

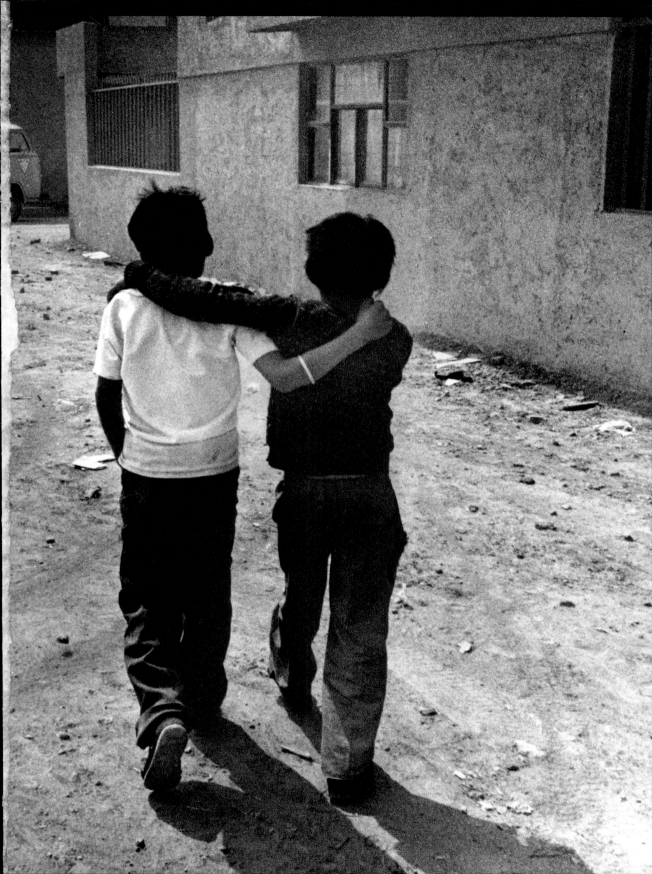

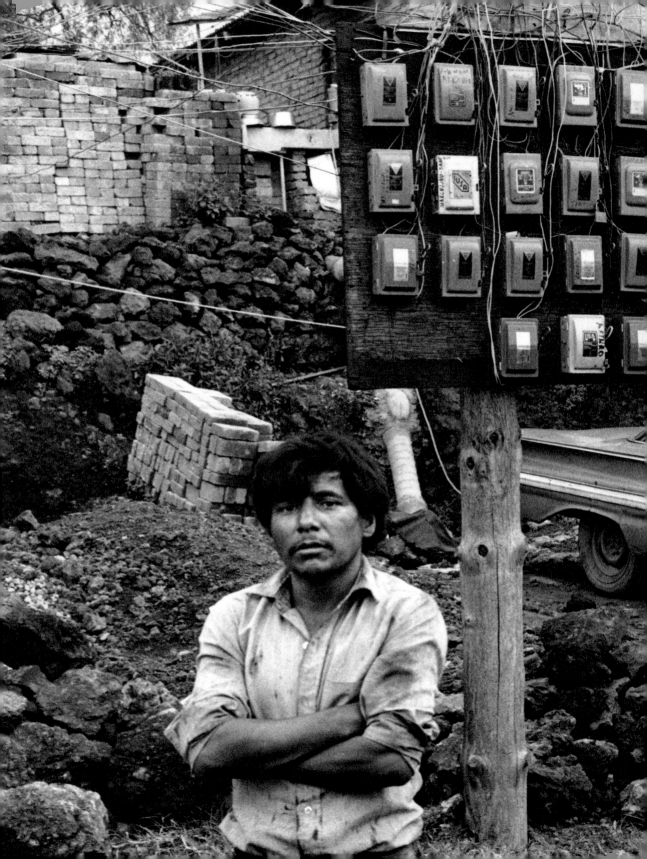

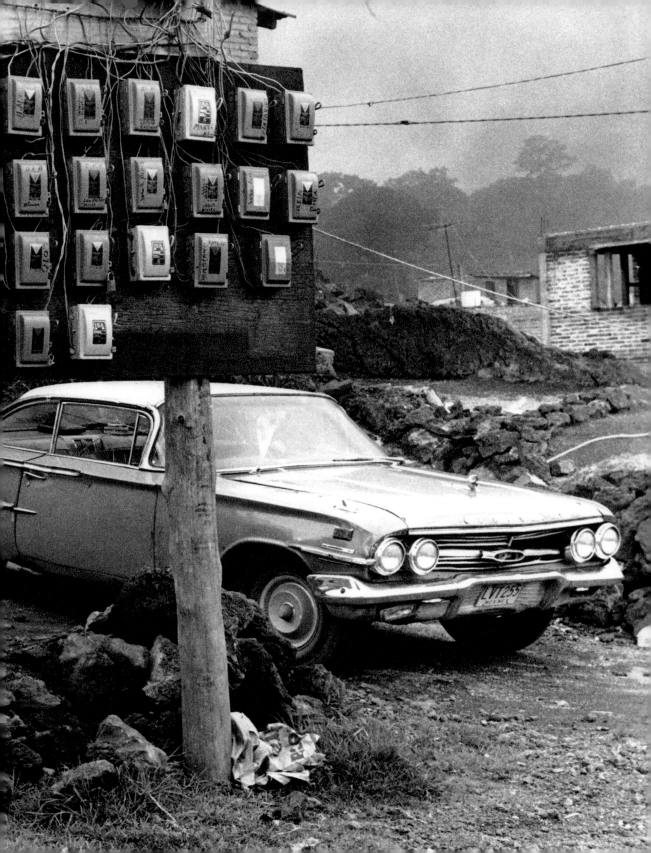

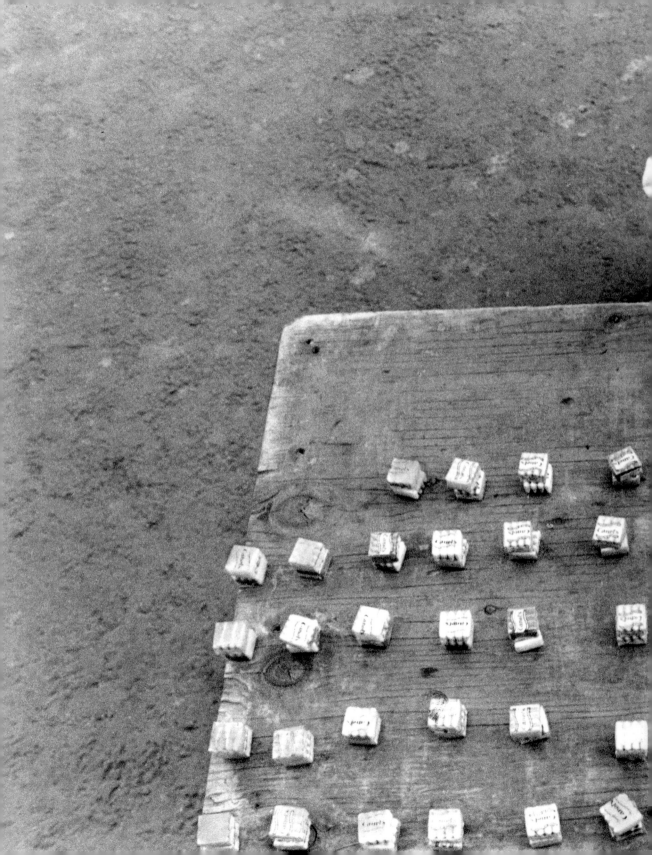

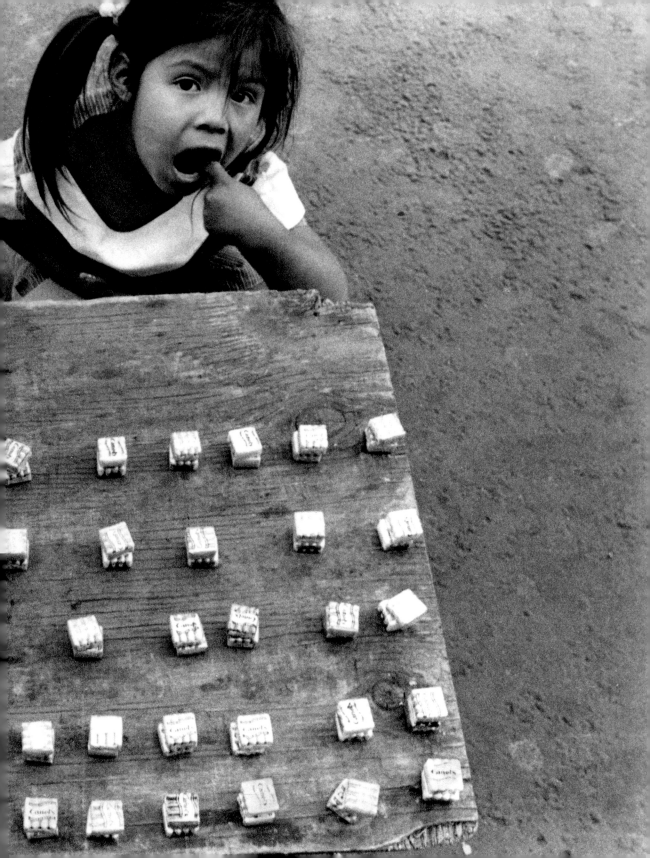

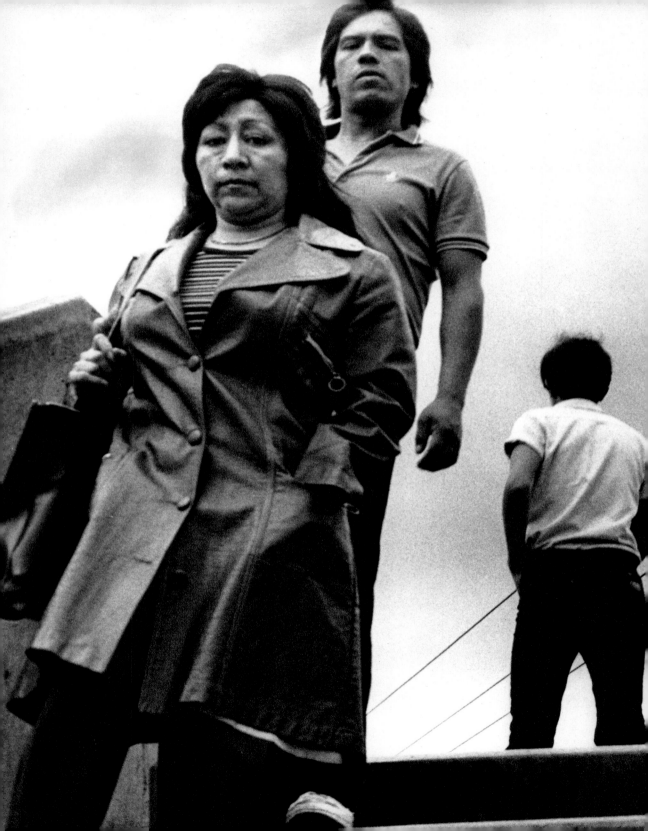

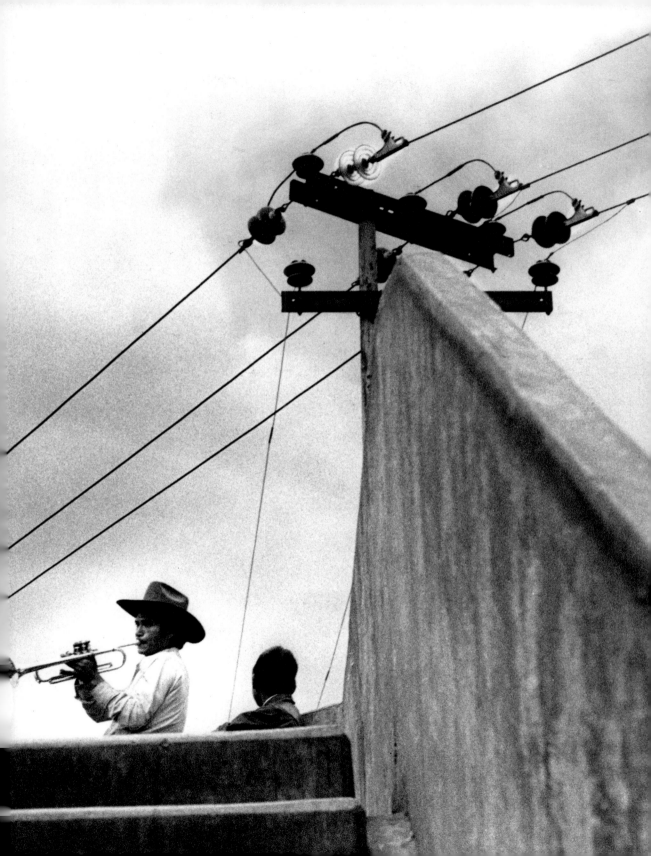

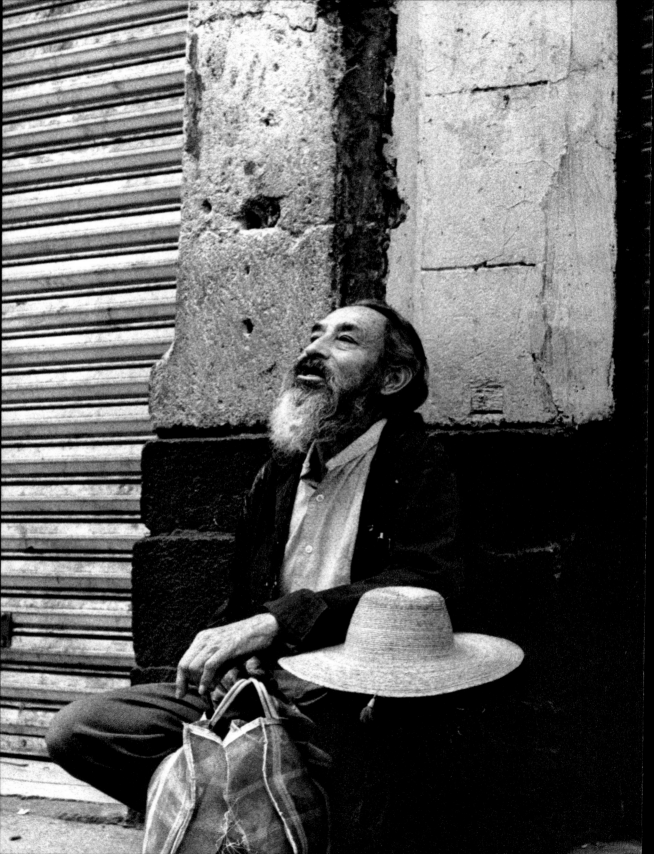

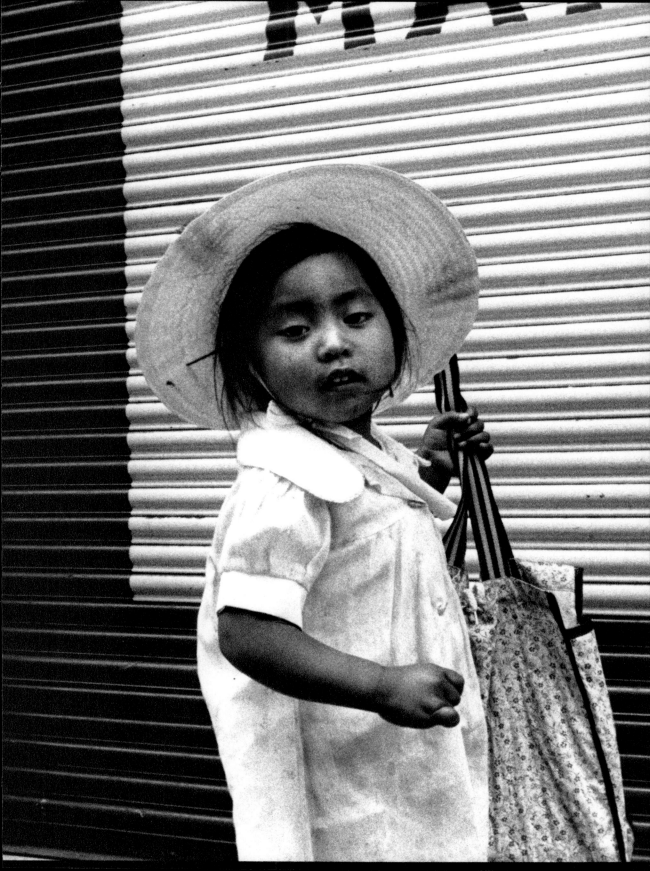

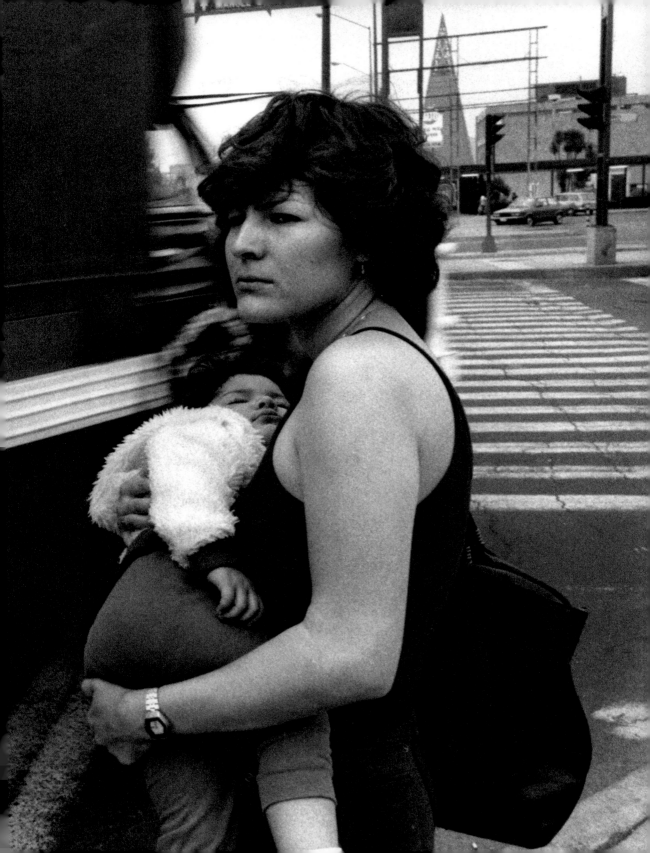

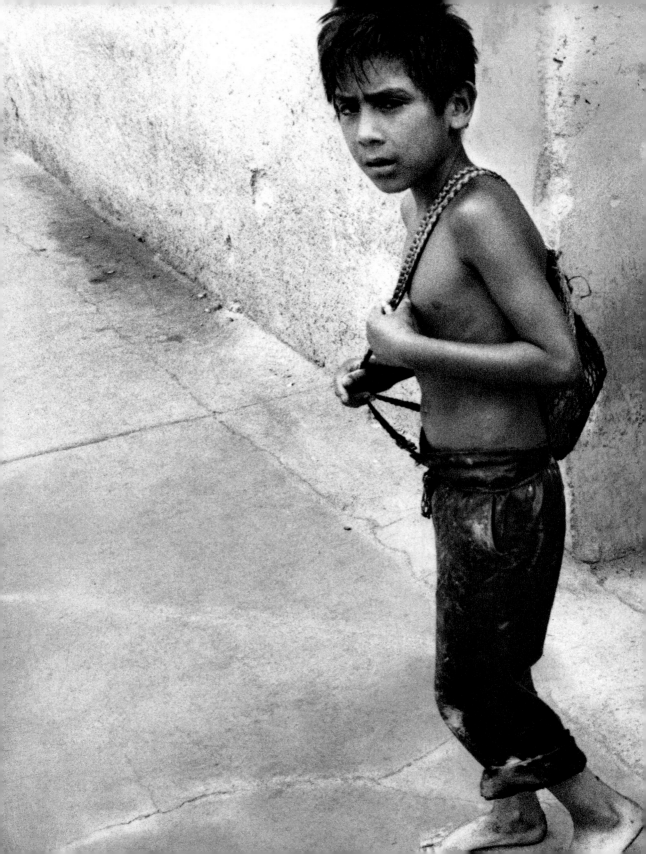

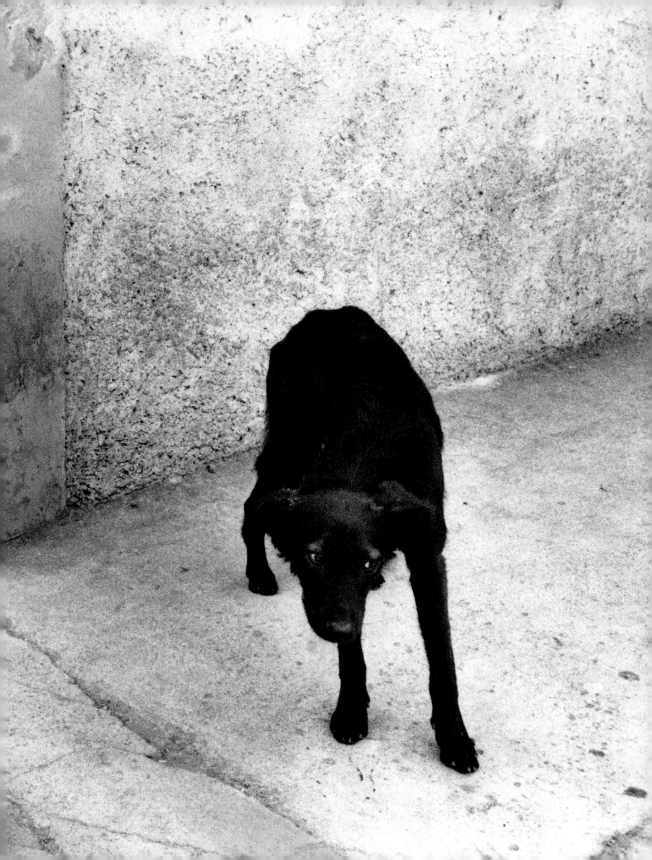

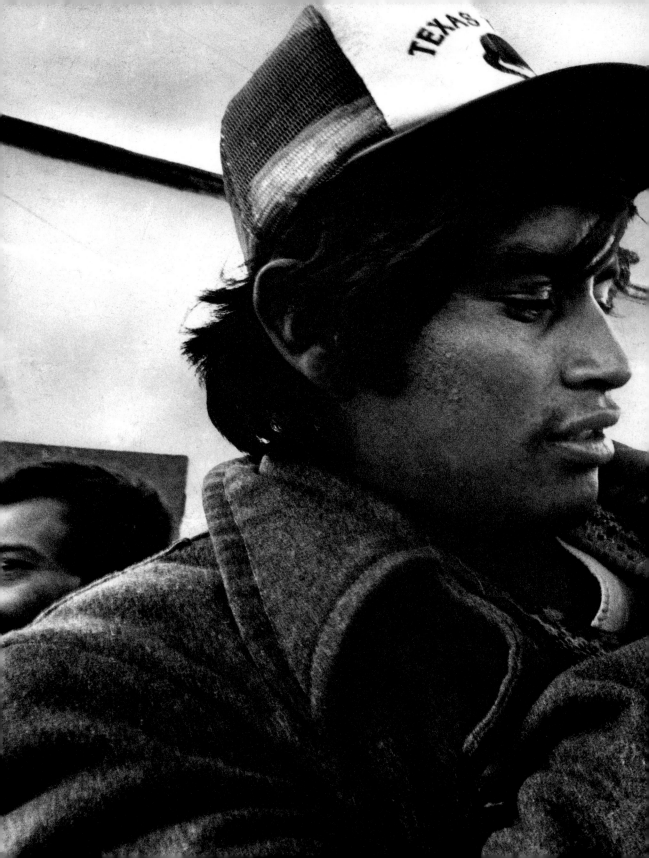

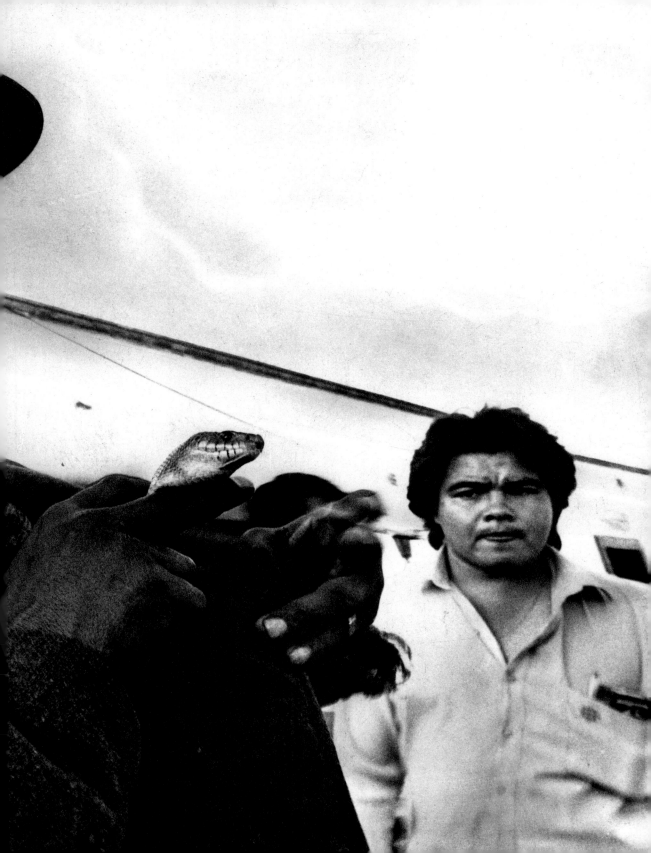

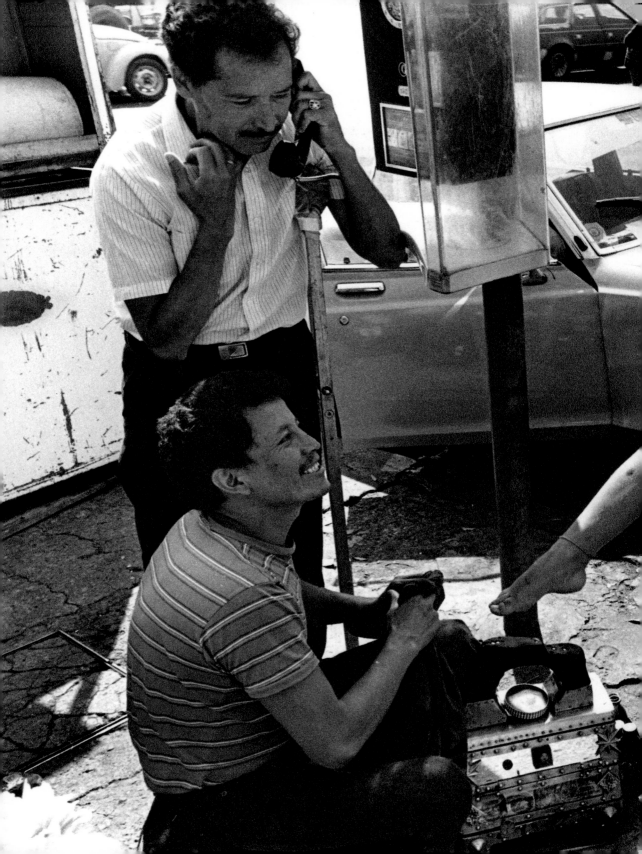

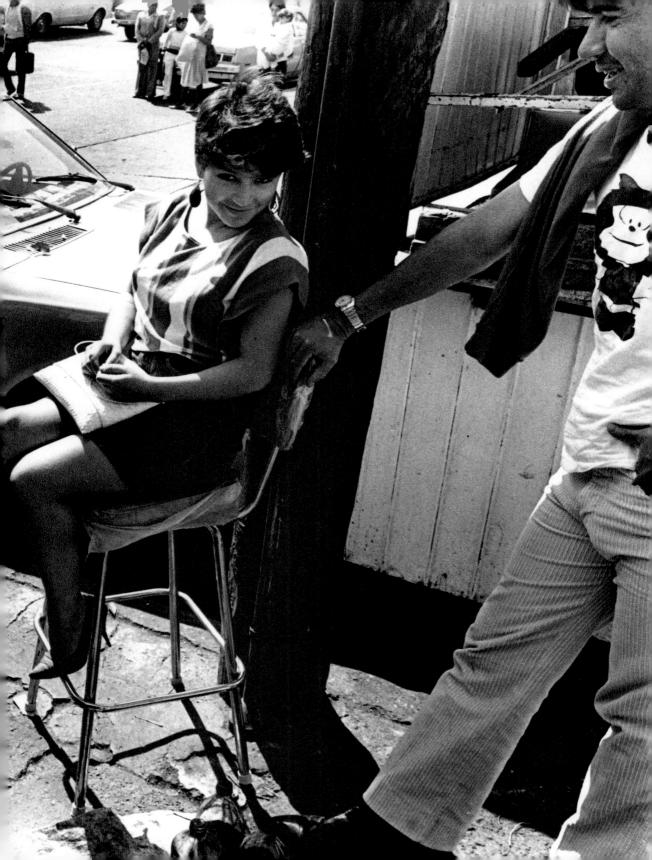

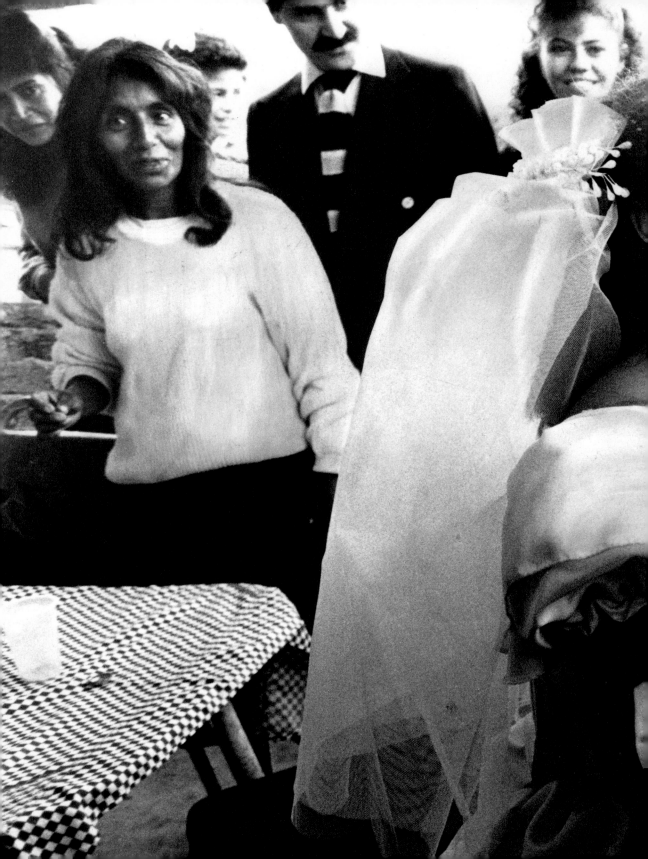

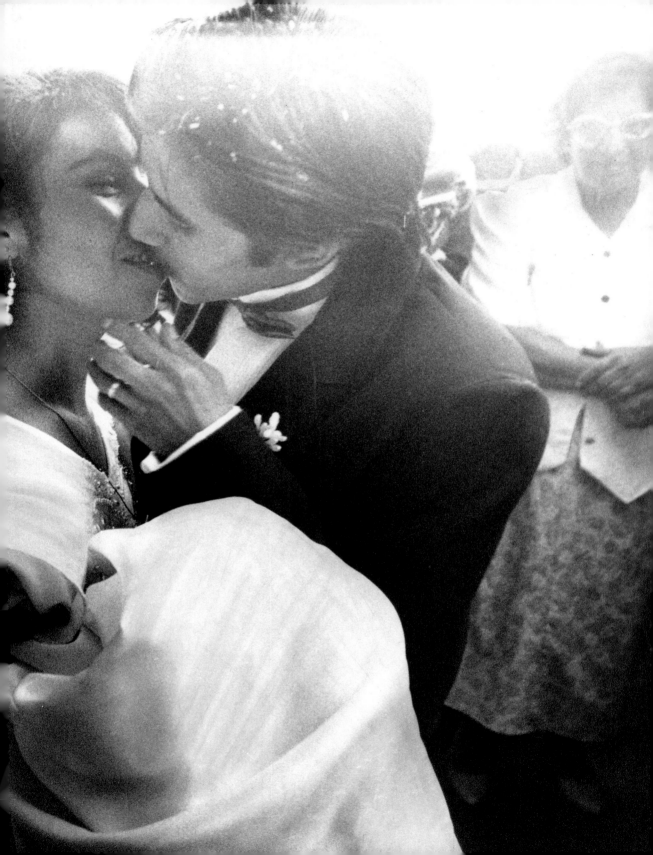

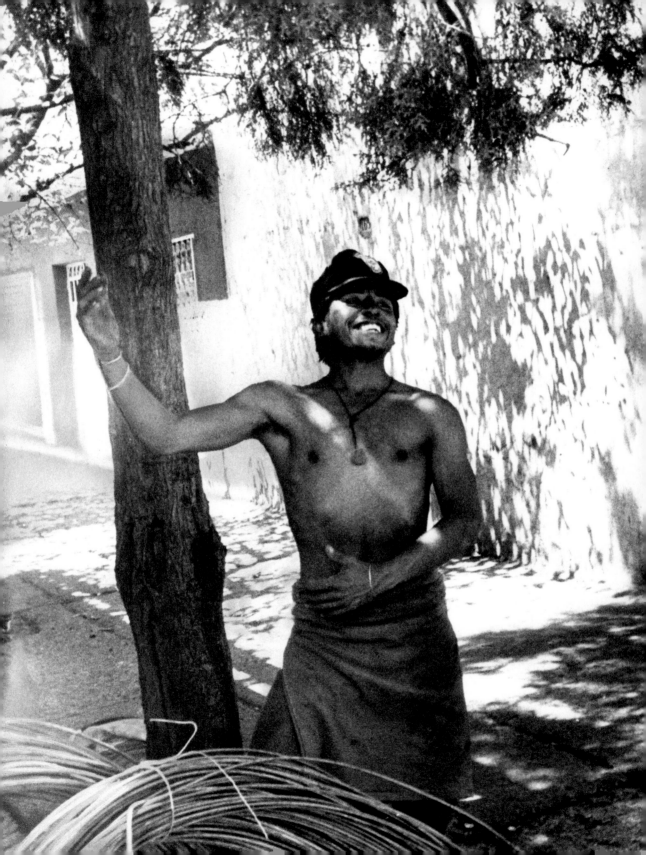

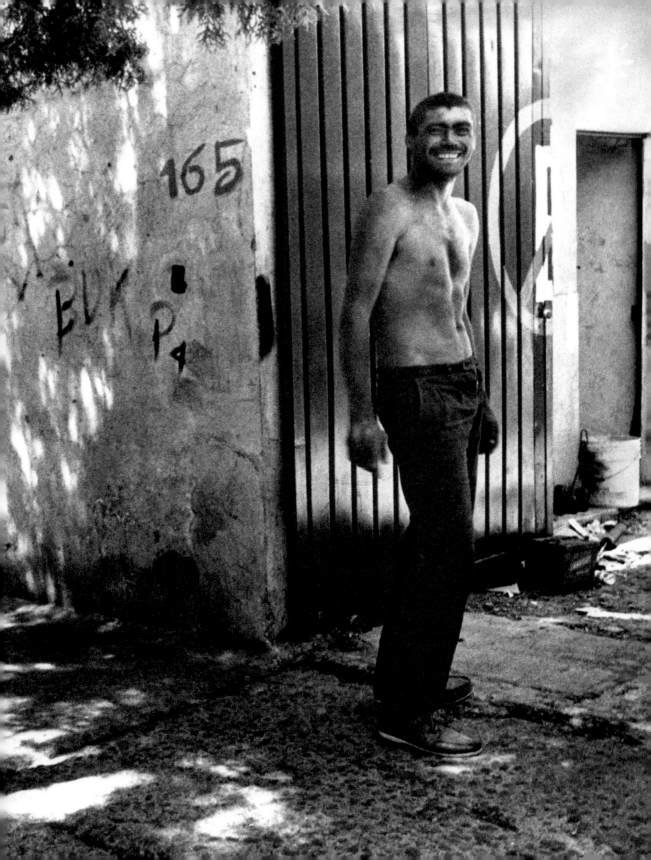

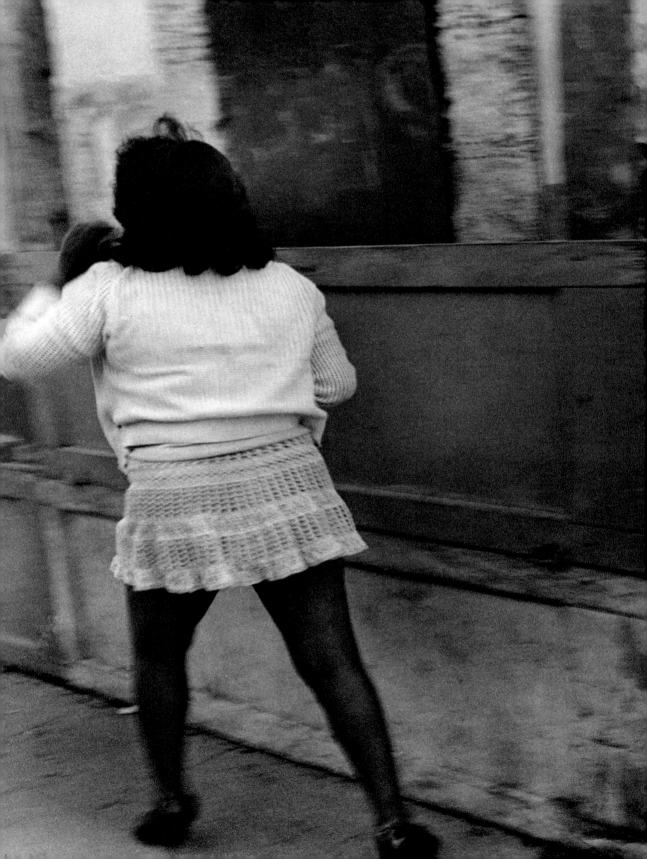

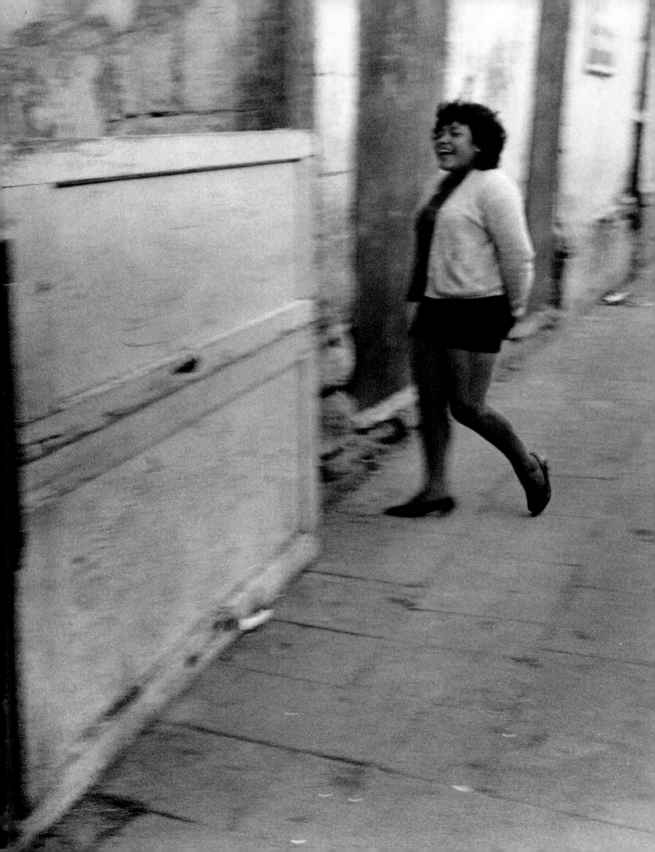

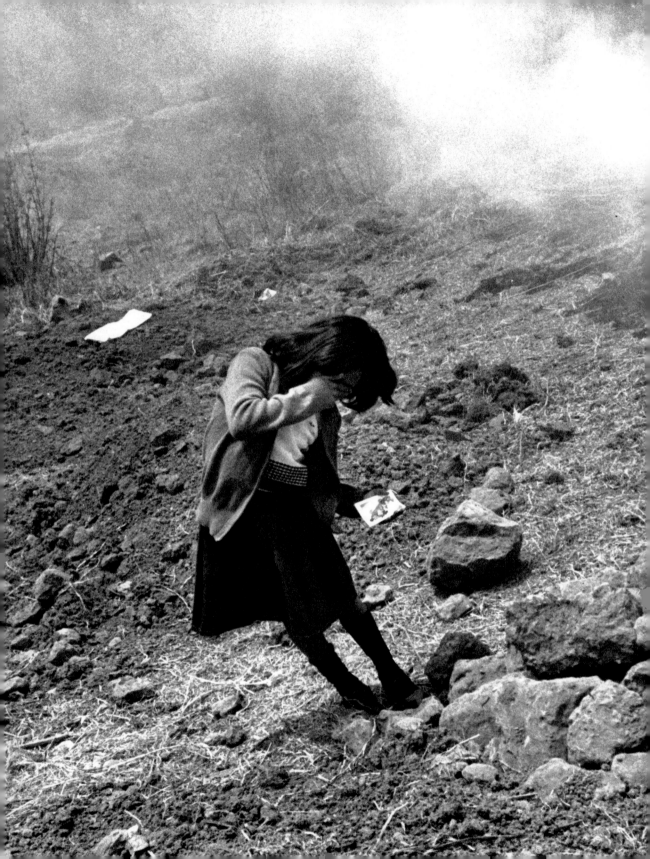

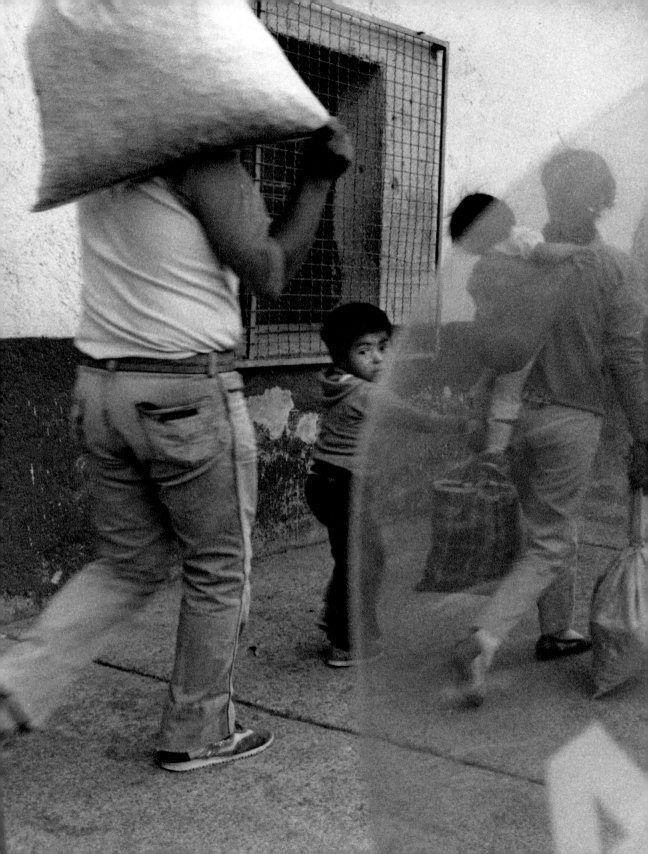

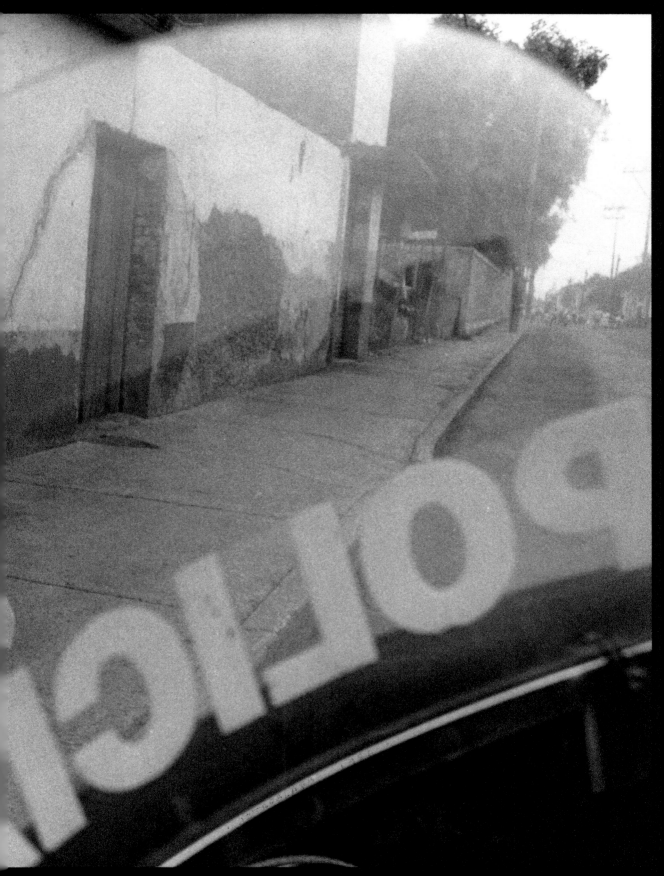

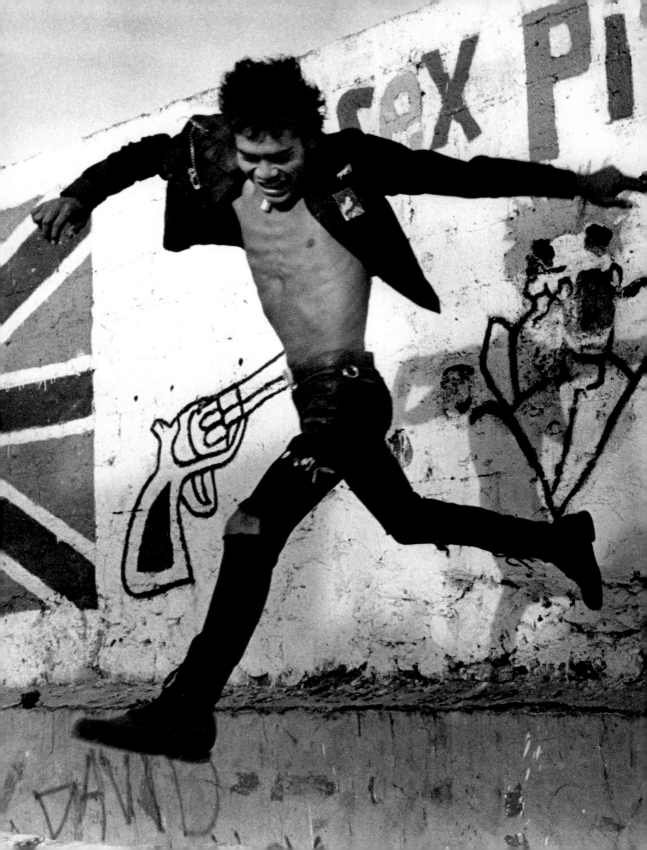

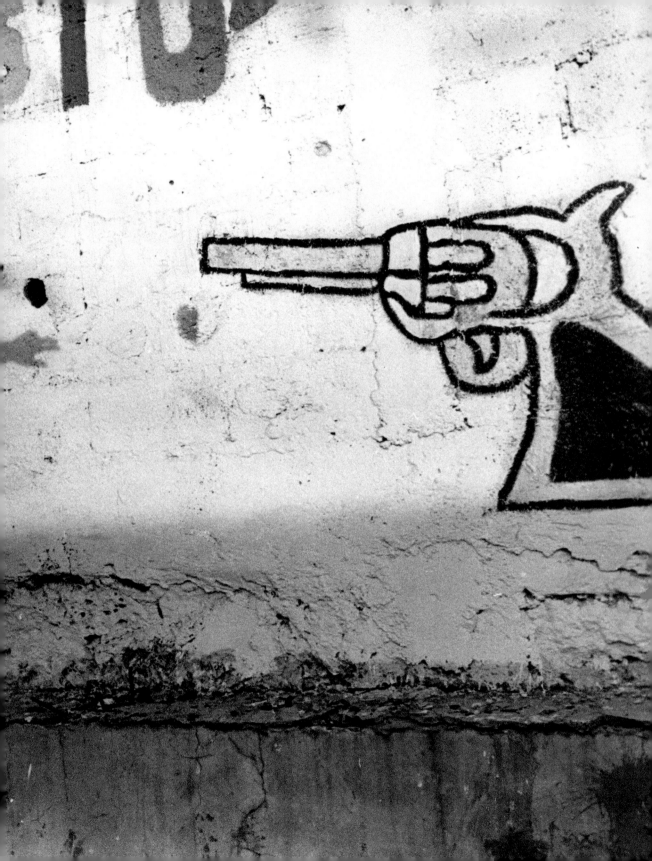

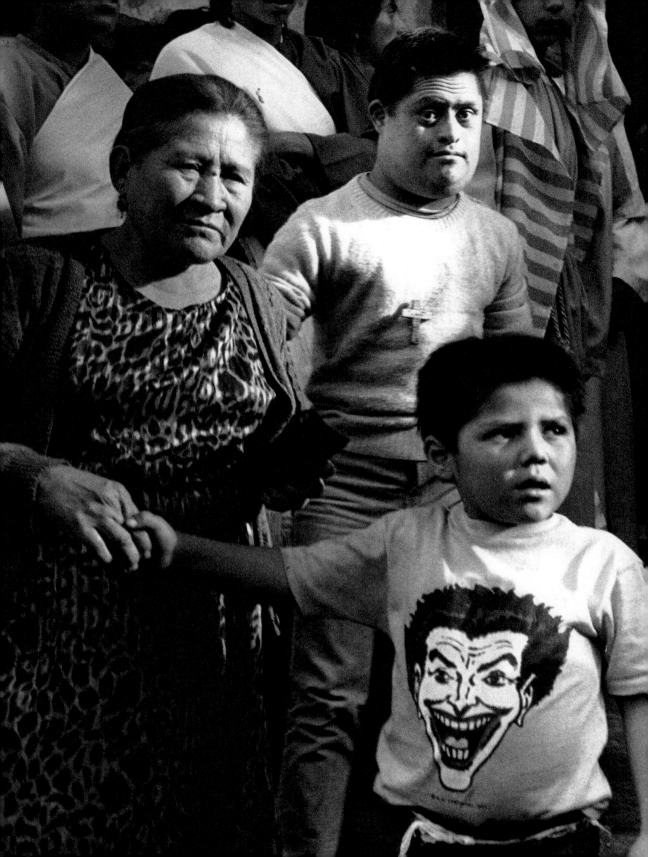

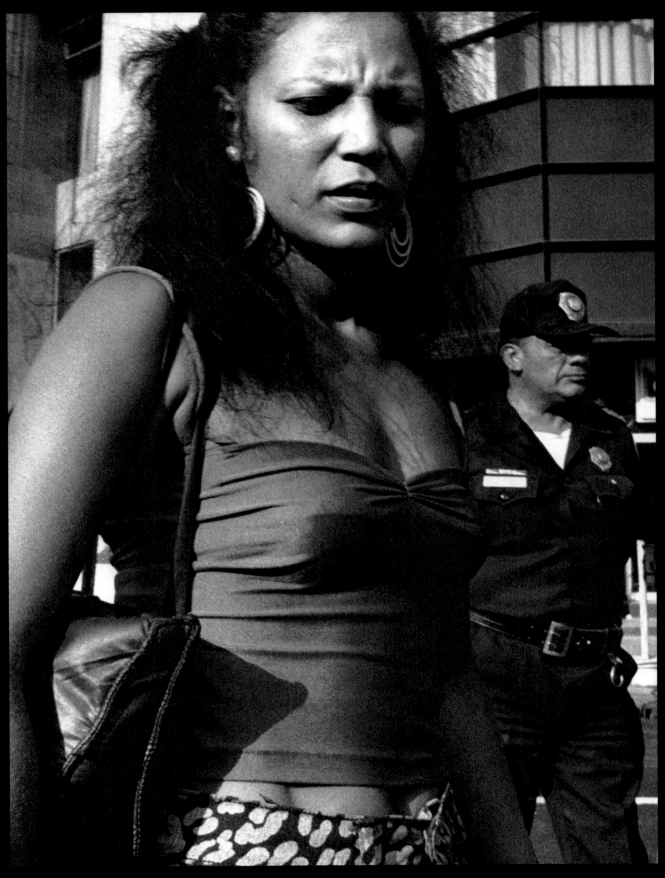

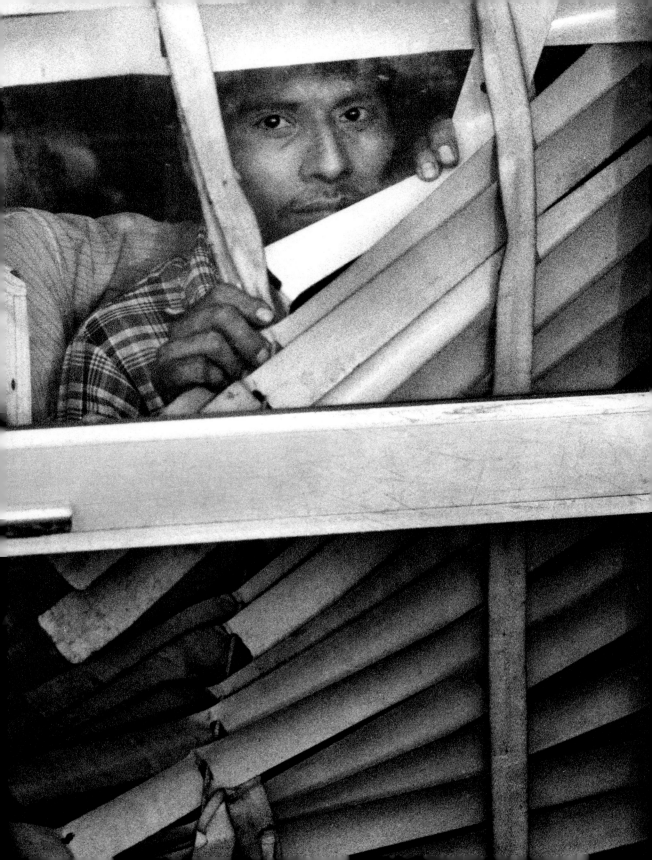

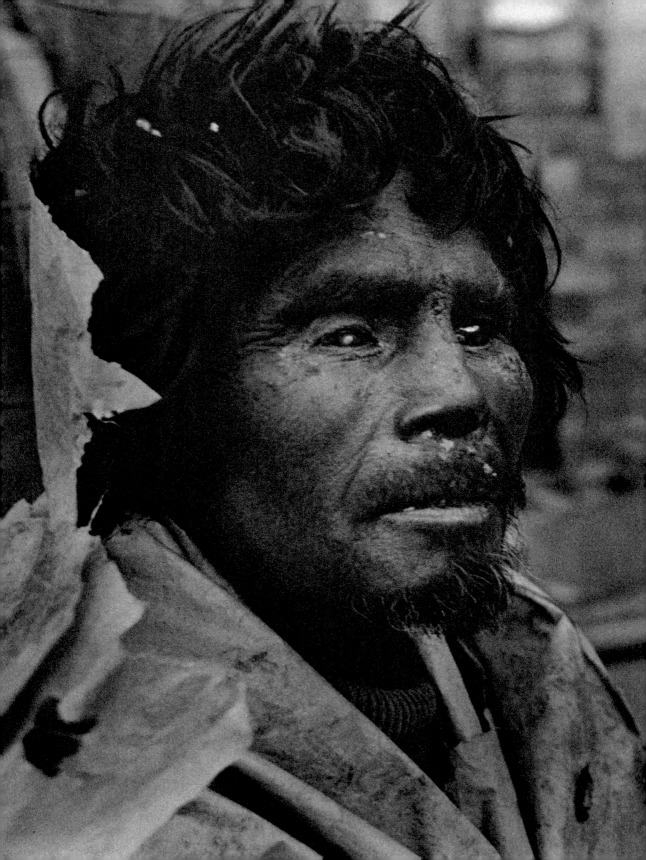

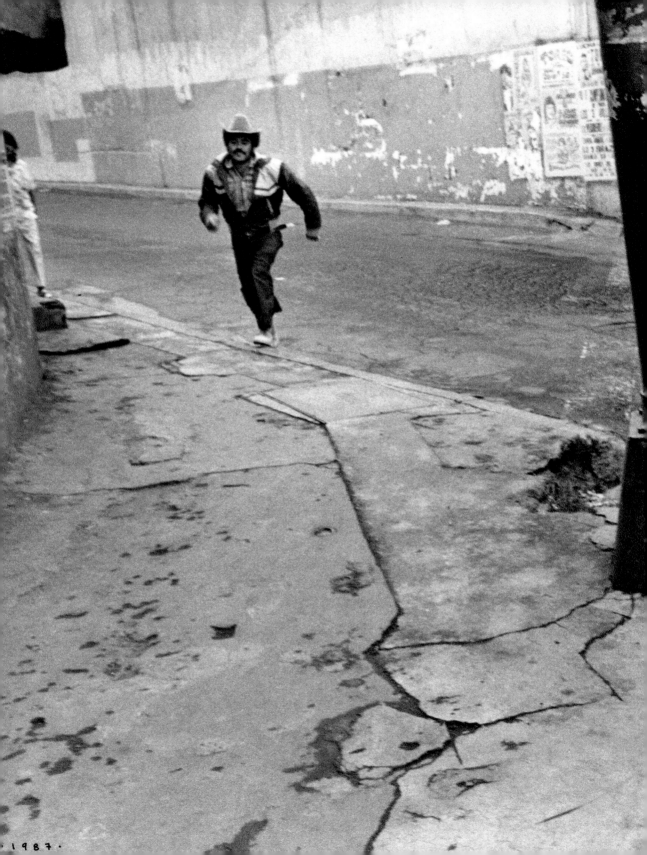

· 1 9 8 7 ·

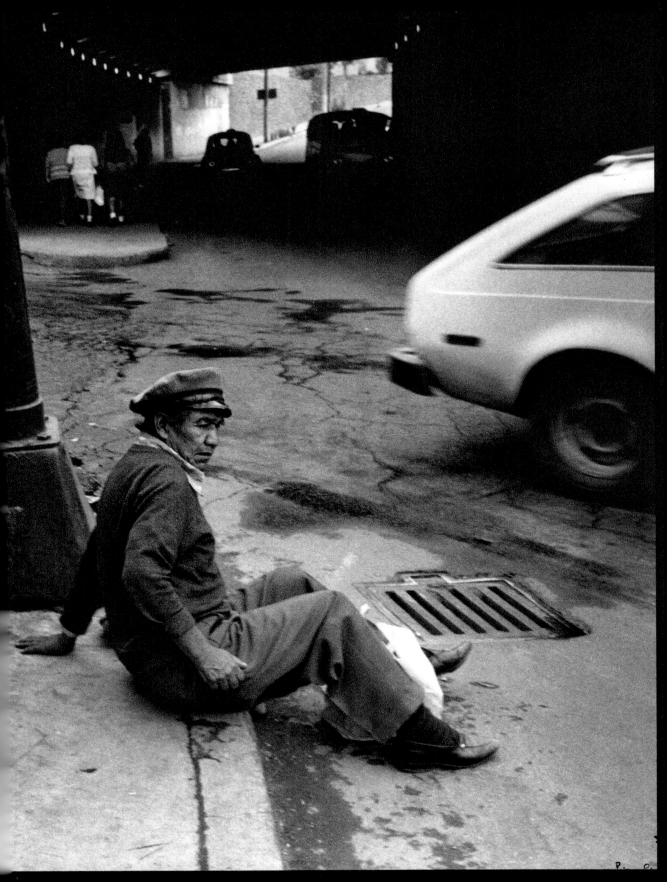

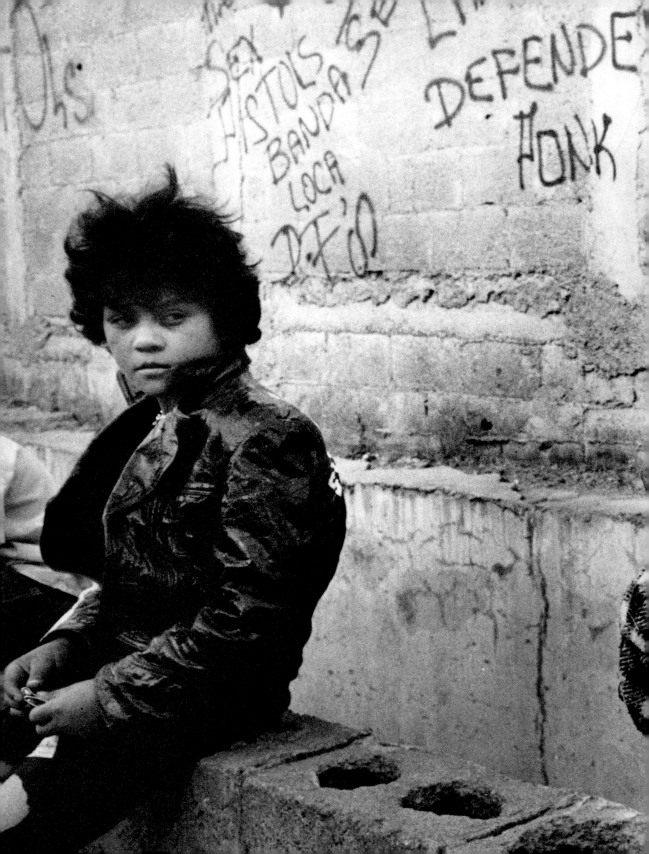

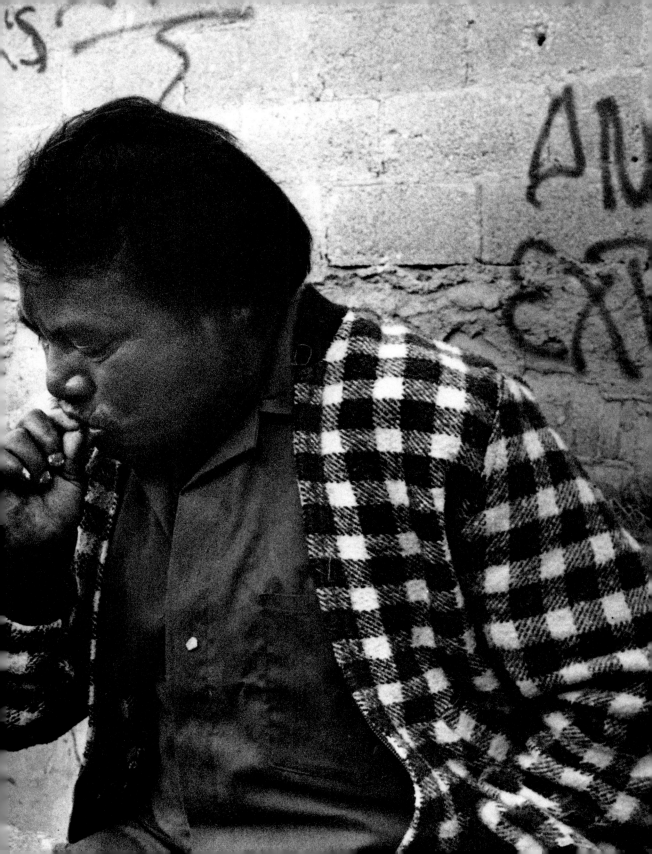

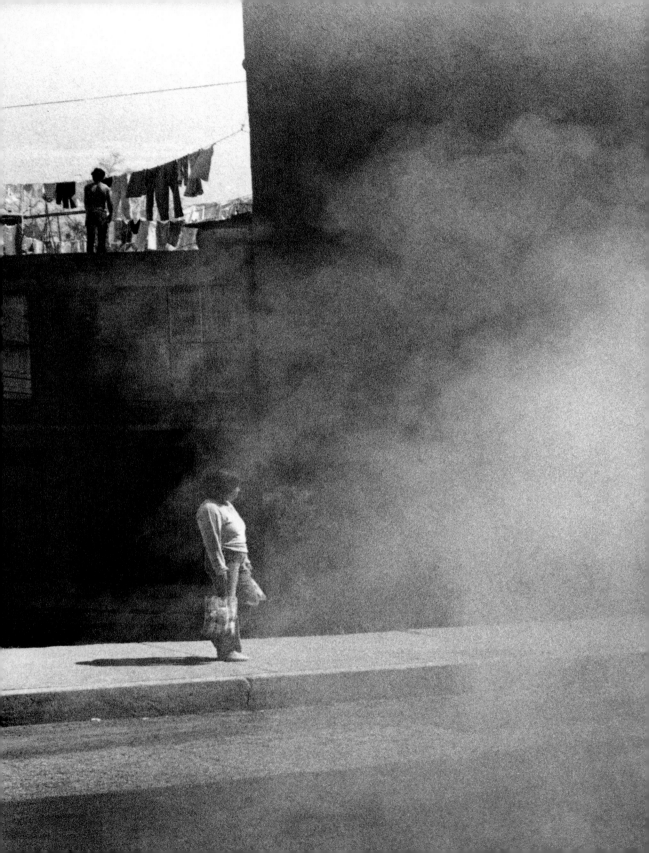

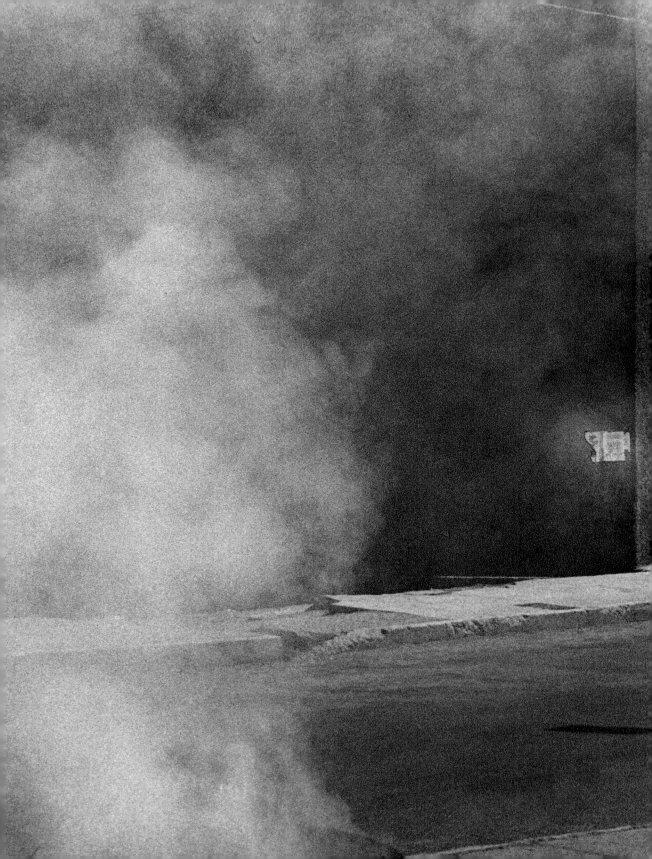

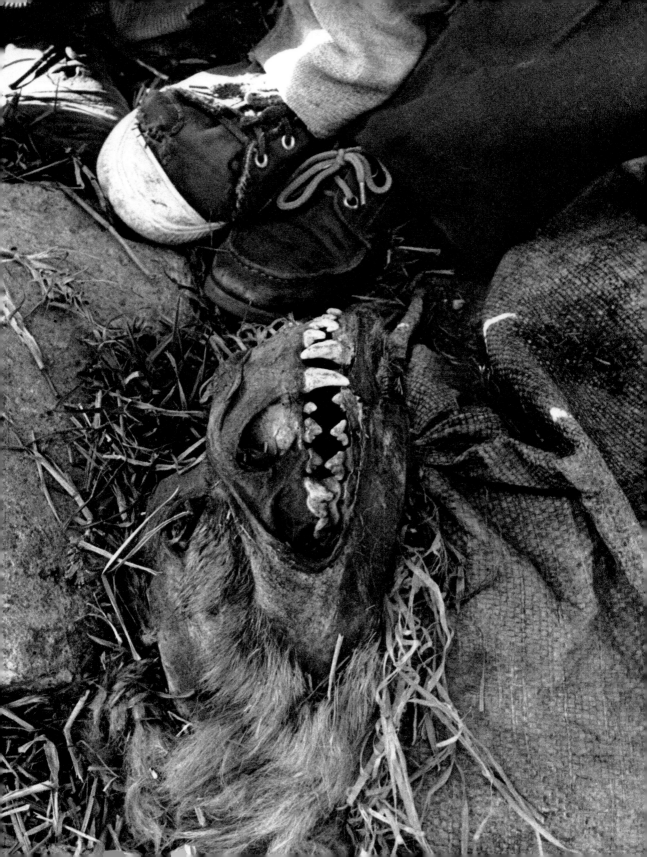

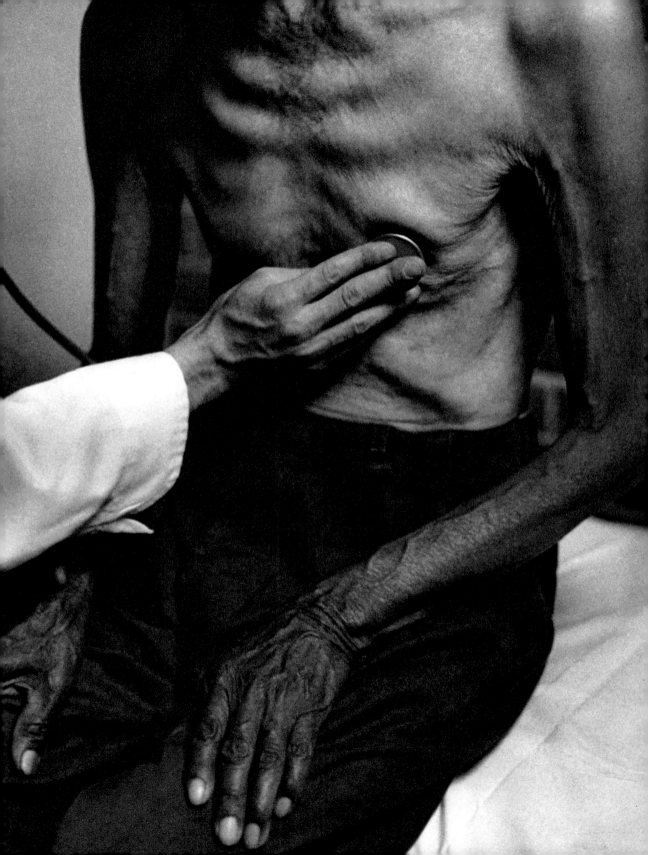

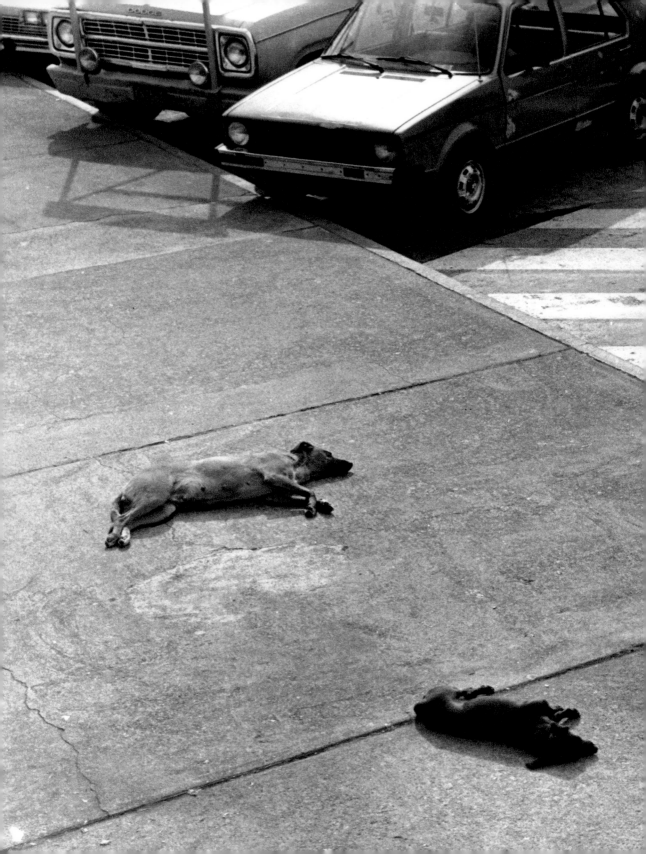

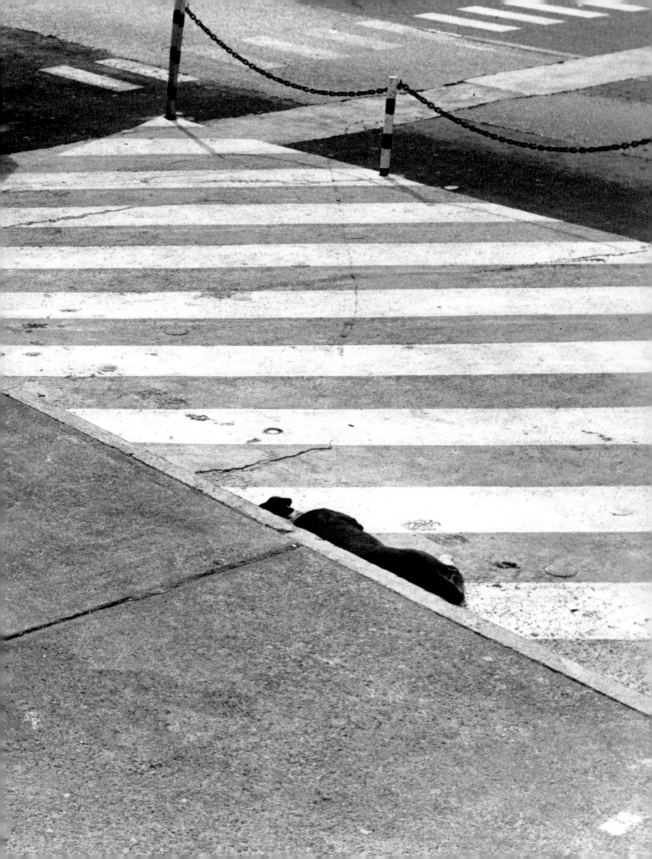

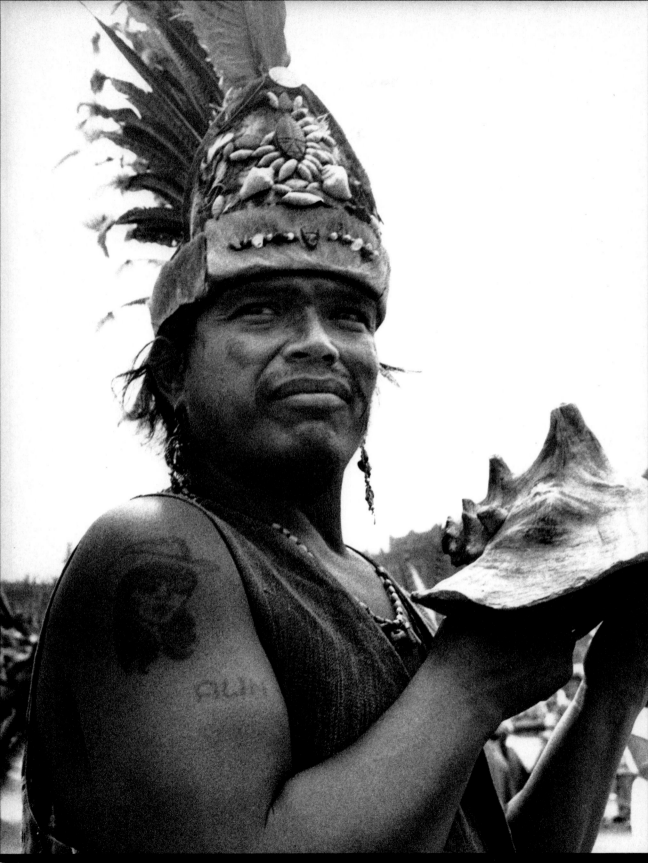

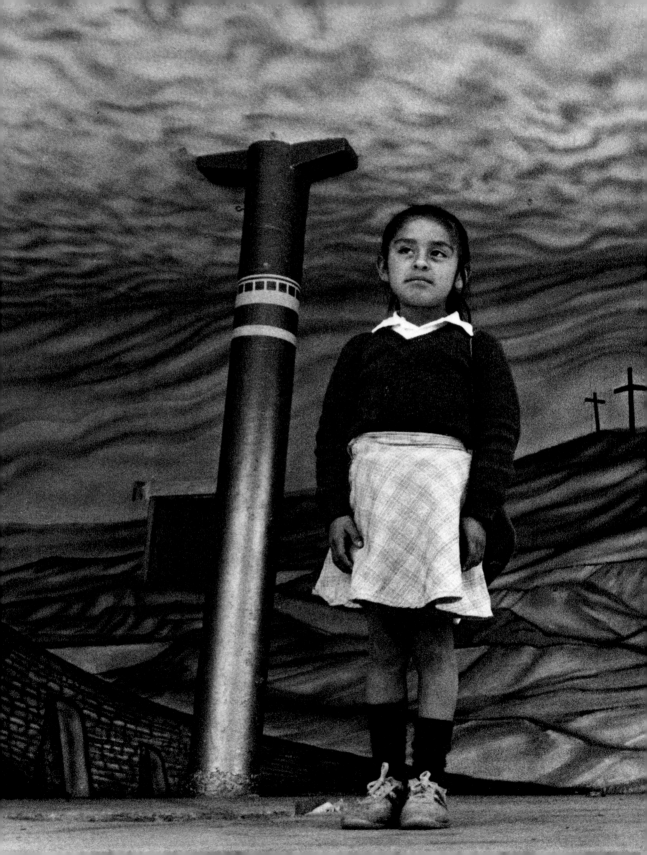

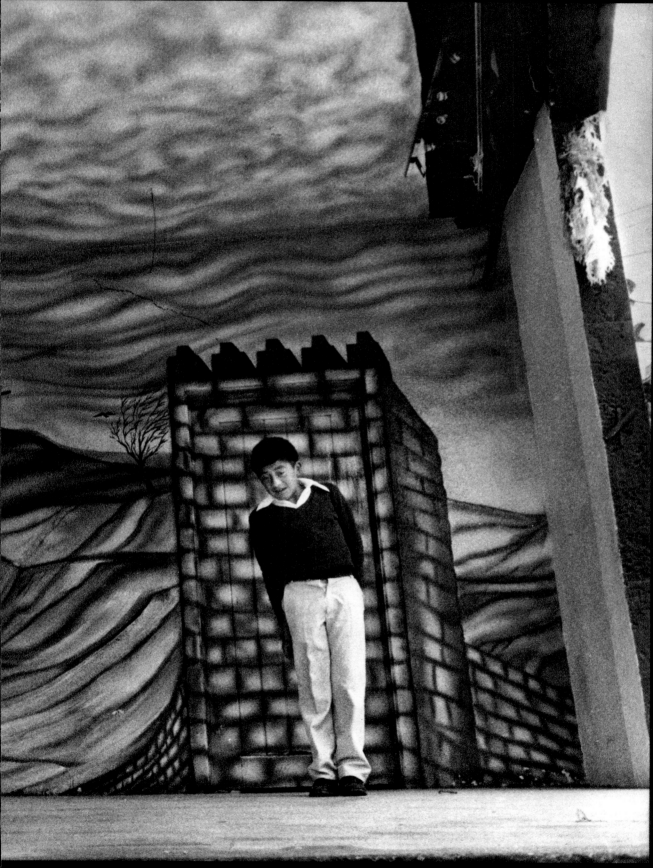

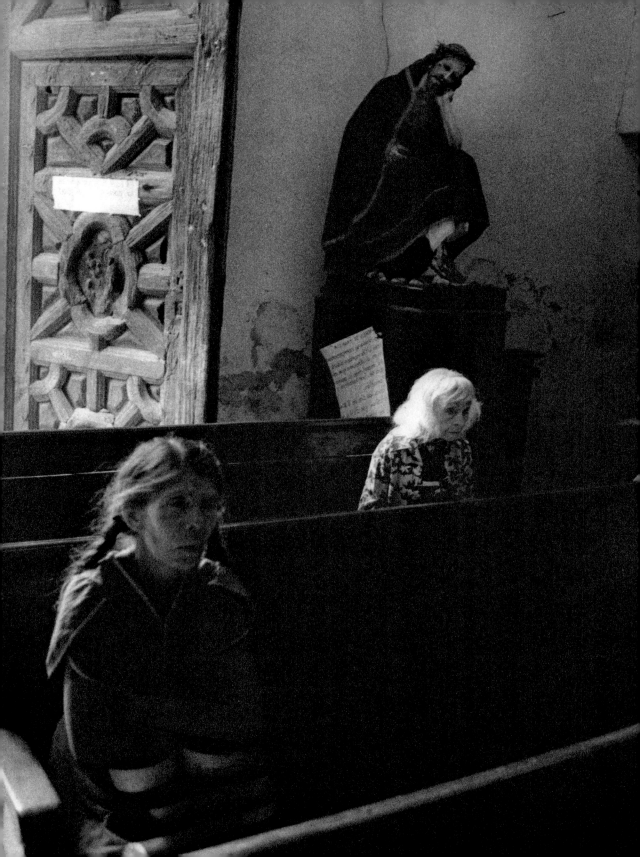

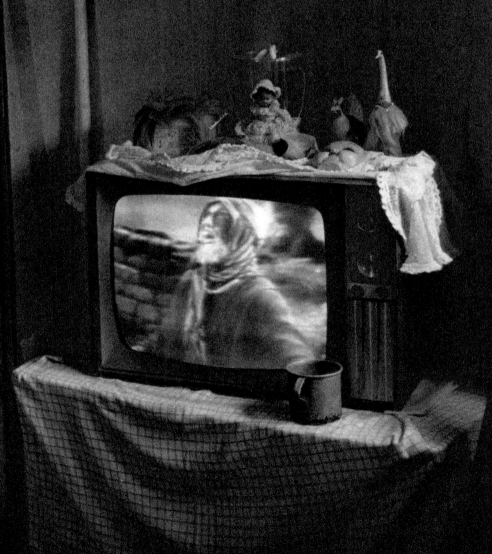

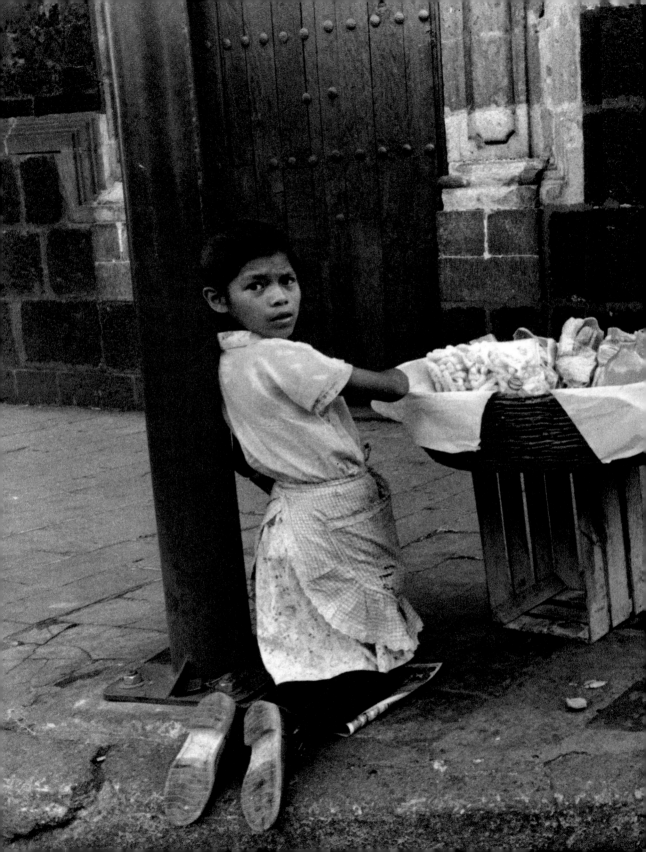

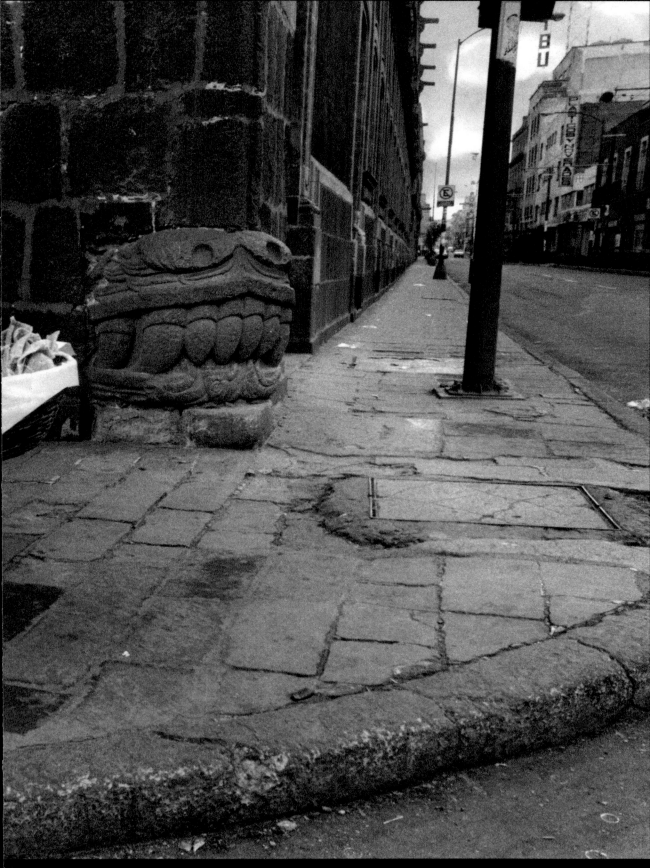

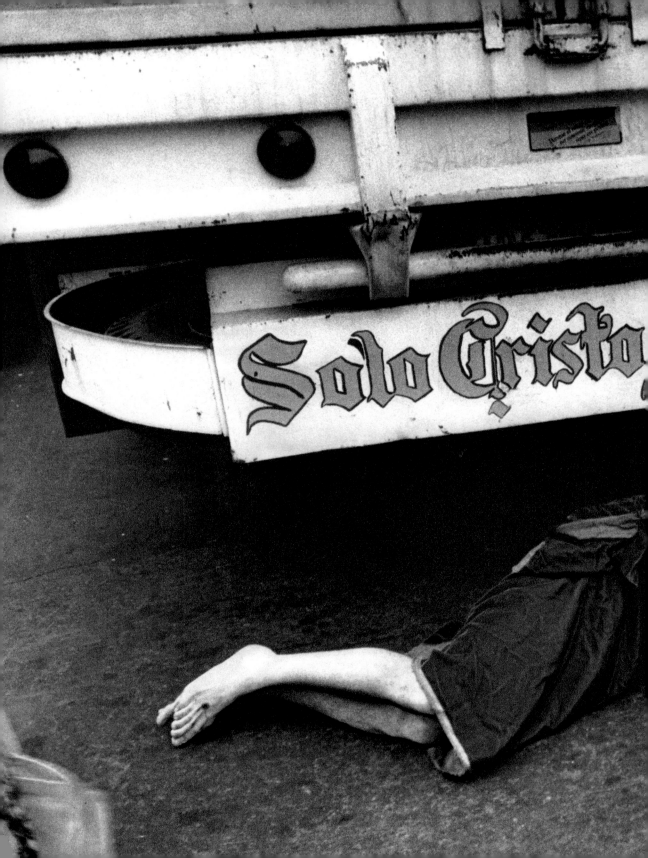

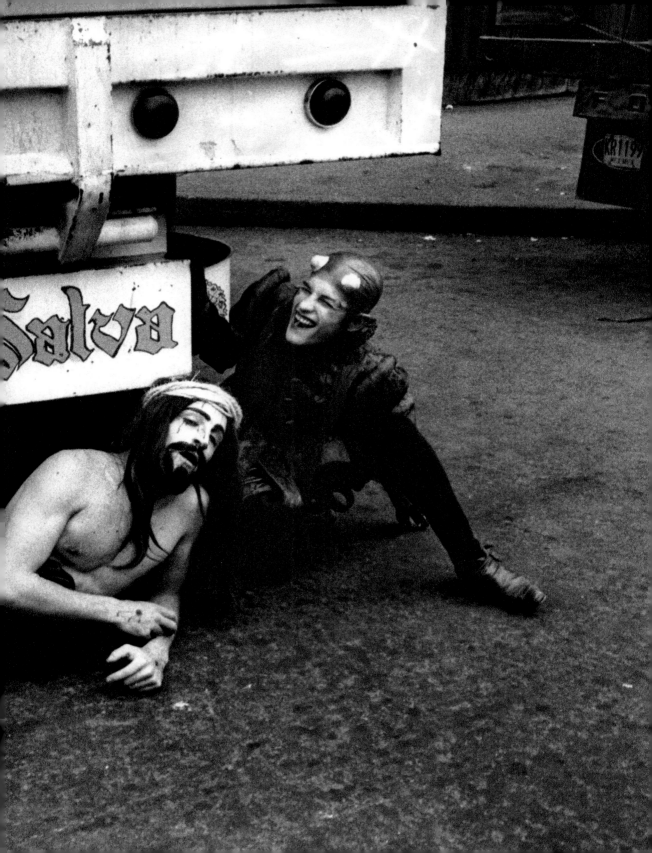

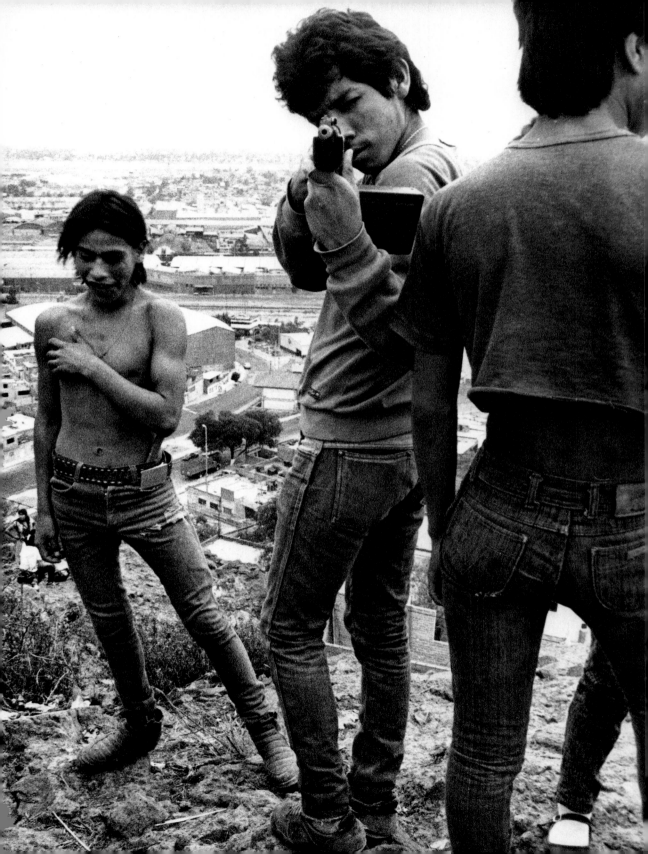

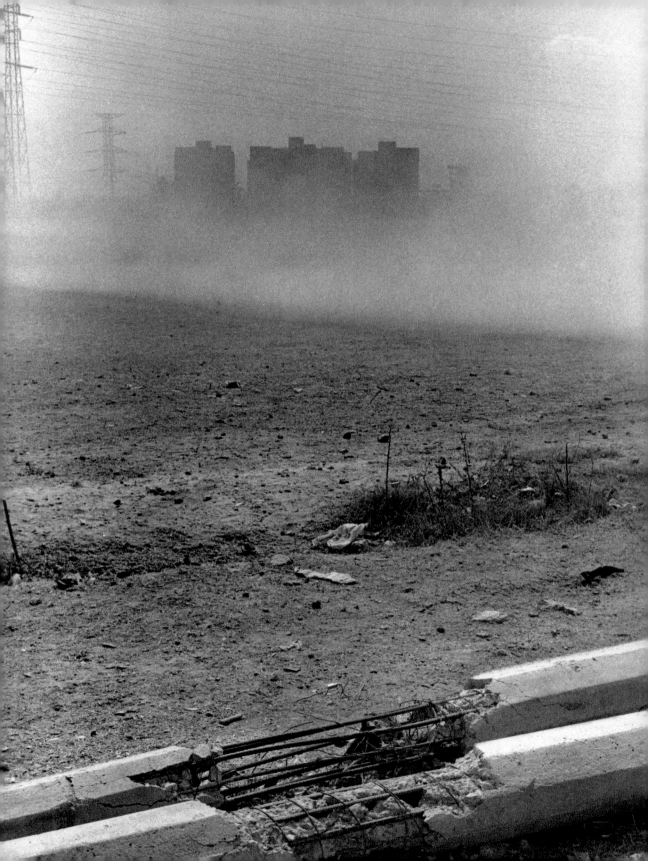

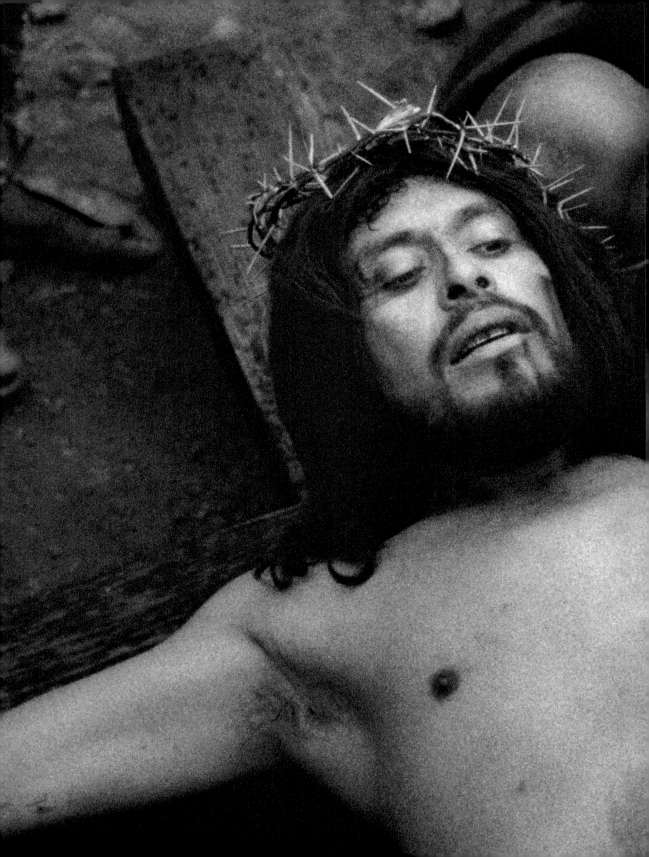

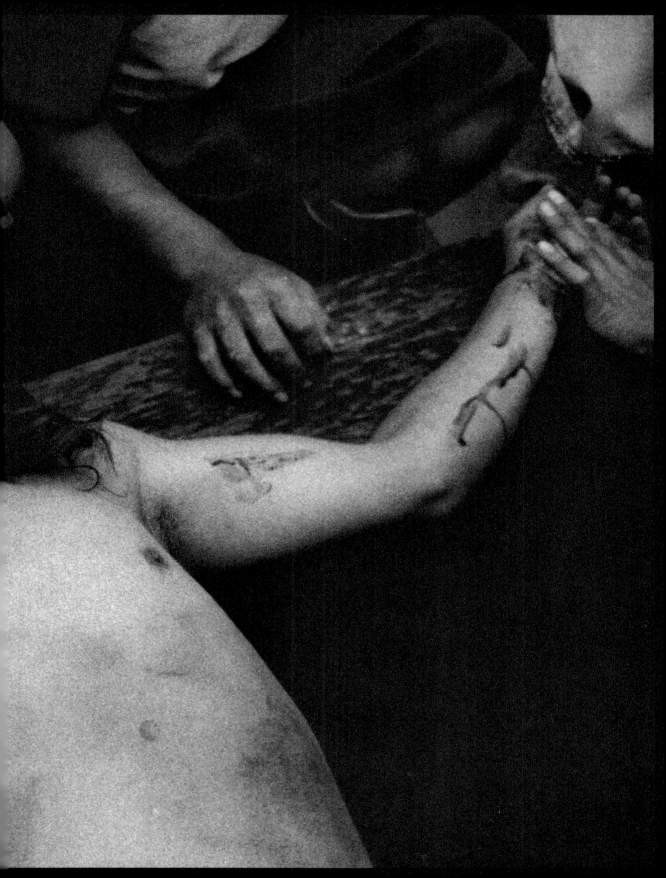

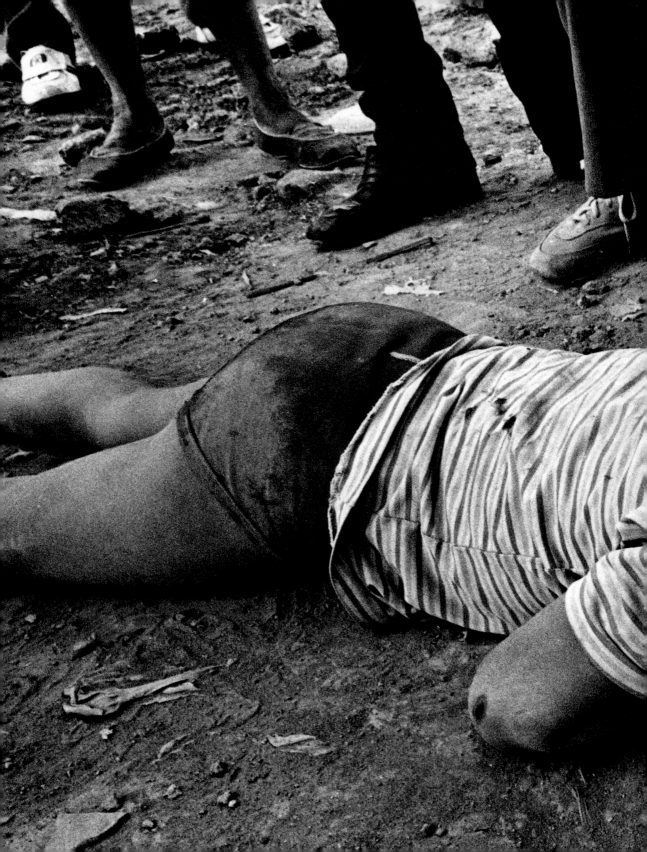

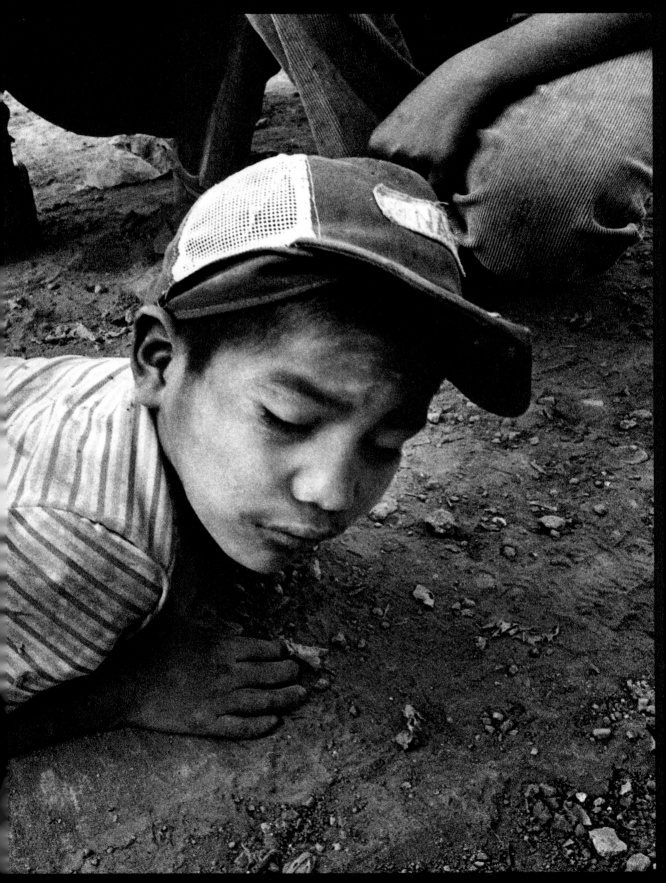

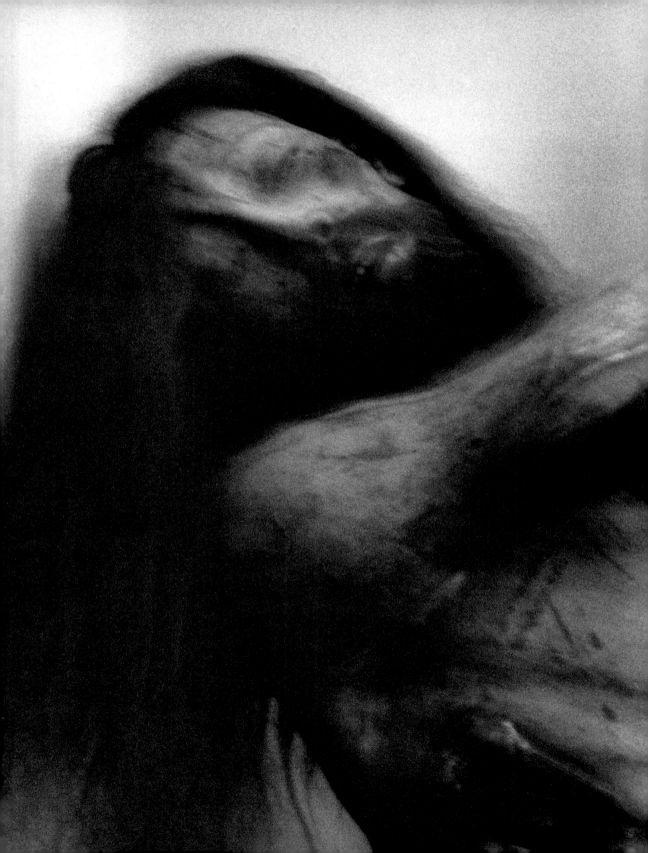

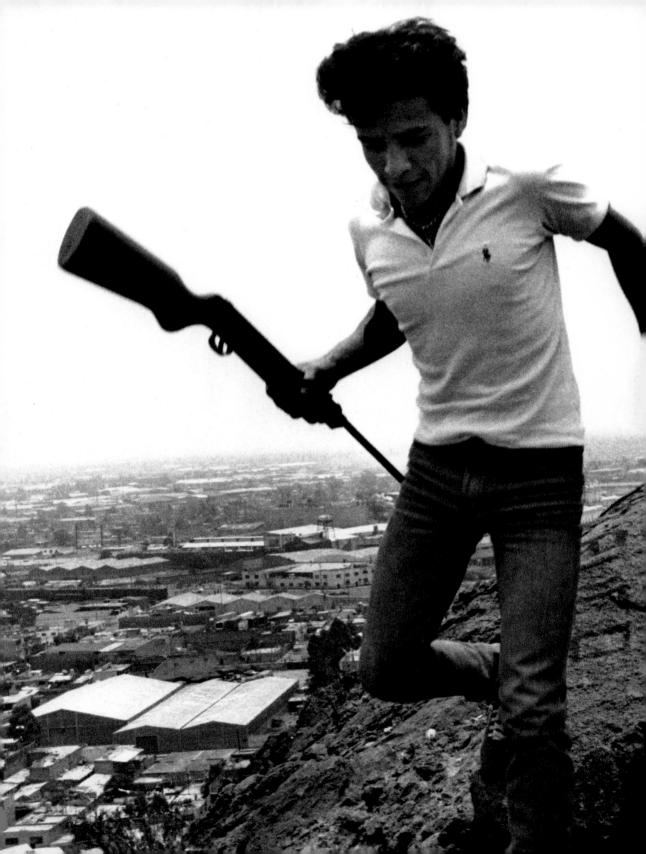

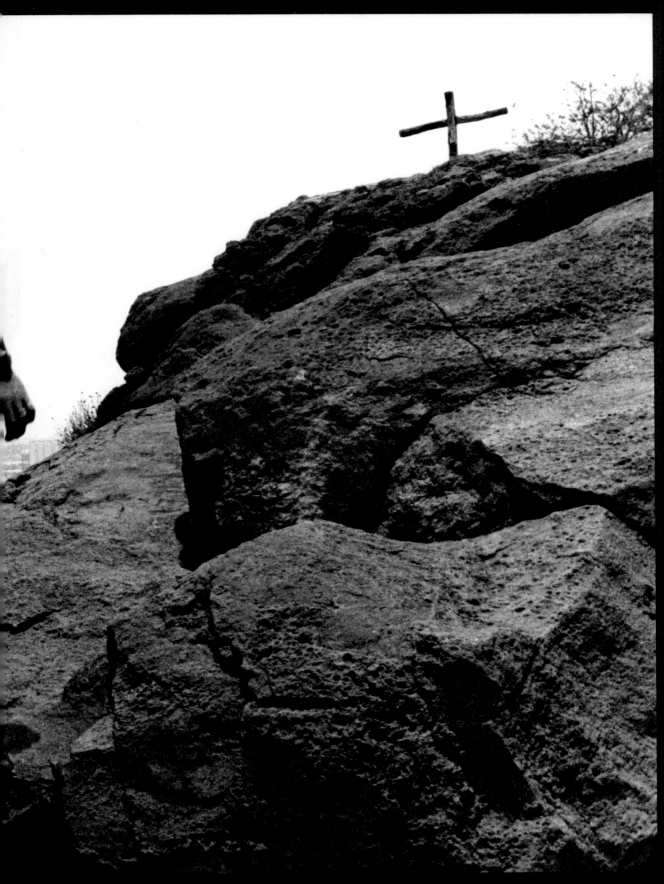

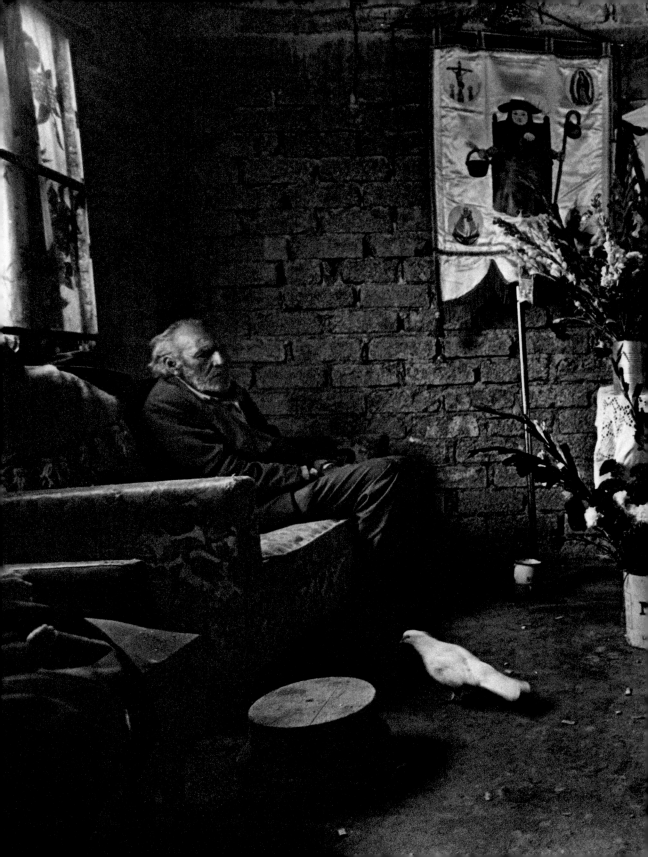

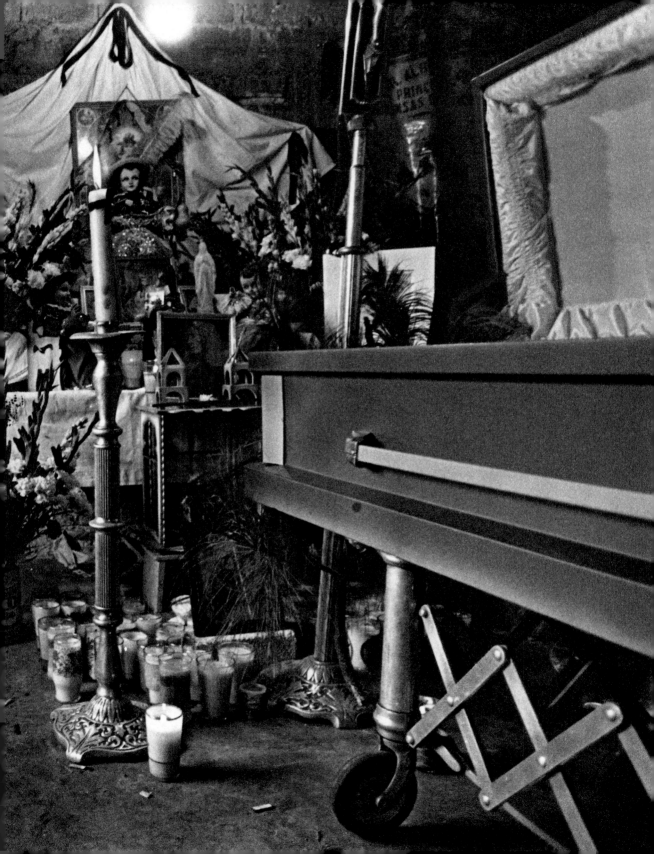

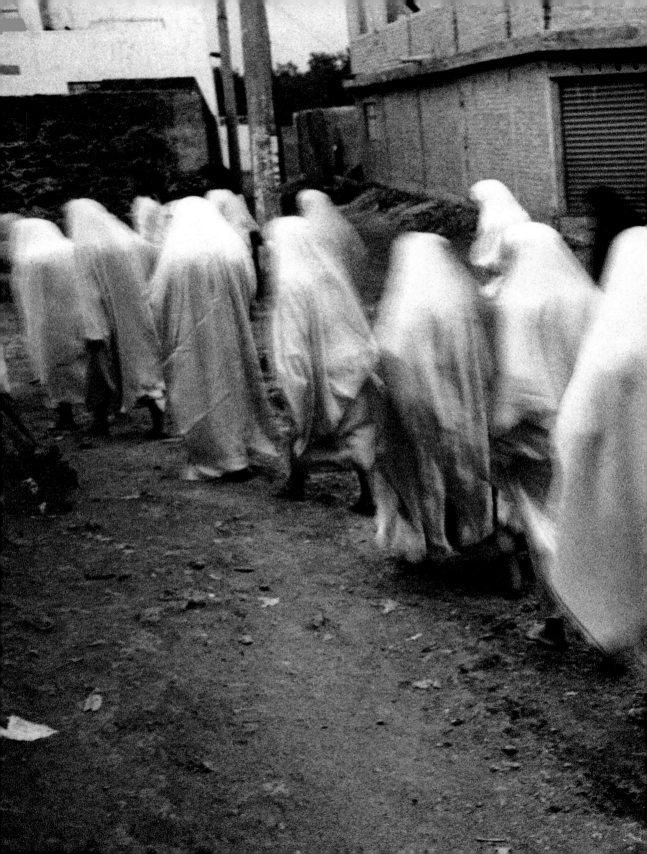

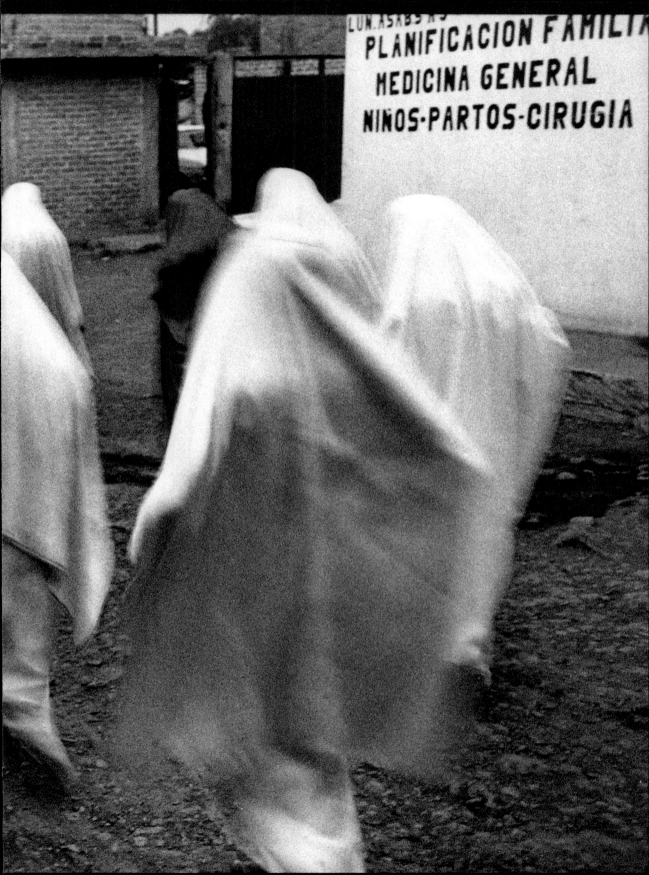

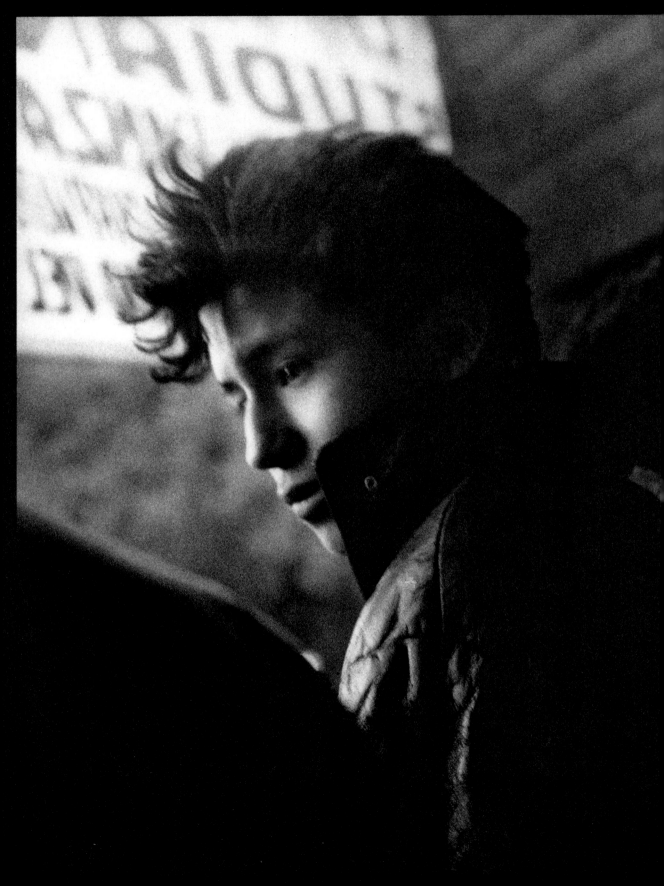

THE LAST CITY

Pablo Ortiz Monasterio is a wanderer in Mexico City. His work here is instantaneous in the best sense of the word: it fixes before us what we would have missed and what would have been lost to us forever if it weren't for his vision and his camera. Stendhal's famous definition of the novel — a mirror carried along a road — could well apply to *The Last City*. But Ortiz Monasterio's is a selective mirror, precise and implacable, retaining only what is worth preserving.

The road is a desert crowded with people, a labyrinth that has come to fill the entire city, and in so doing has lost its name. Ortiz Monasterio has wandered about an infinite theme: the last city or the first "post city," a tragic honor that Mexico City shares with Los Angeles. Every prophesy about these cities has yielded to the unspeakable reality, a reality that foreshadows what all urban life could look like in the next century.

Mexico City is a postapocalyptic city. It has refused to accept the many declarations of its death. It survived the devastating earthquakes of 1985, and has withstood over-population and pollution beyond the assumed threshold of human tolerance. The country has attempted to enter the twenty-first century without yet having solved the problems of the sixteenth. Ortiz Monasterio doesn't offer solutions, nor is that his role. Rather, his mission is to bear witness and create art, to write with light and shadow.

The city is its people, Ortiz Monasterio's images seem to be telling us. Of course, he doesn't ignore the milieu within which these twenty million or more human beings live out their lives. He records, for example, the television antennas that connect our megavillage to the global village and

exhibit mirages of consumption to the ~~ who cannot reach them. Above all, today Mexico City is a city of the poor; it is the poor who at the close of the twentieth century, are its natural inhabitants. The rest of us, though we may have been born here and we live here, have become foreigners.

Their misery impoverishes us and shames us. As the saying goes, we're all in the same boat, this shipwreck of a city that floats upon the mud of its dead lake, upon its fault lines, and upon its unresolved social problems in this era of rich against poor. The thought of its demise is painfully comforting, and for a moment absolves us of any attempt at solution. We ask ourselves: Why try? There is nothing to be done; sooner rather than later the city will self-destruct.

But Ortiz Monasterio rejects resignation without becoming preachy: he shows. Life goes on and he, through the act of portraying it, places himself on life's side. In spite of all the disasters and the suffering, he defends life and praises it. A couple embraces at the top of the Torre Latinoamericana, and in their embrace they make the immense and alien city their own. It has excluded them, but now it's at their feet, new and ancient, a different city for each inhabitant. Juarez's head recedes and in so doing becomes more present. A little metal horse raises its head to the sky. And in this unexpected juxtaposition, resistance and hope seem to come together.

Amoung the ruins of what never was — those ubiquitous cinder blocks a symbol of always-unfinished Mexico — a quizzical group of turkeys don't know what awaits them or perhaps they have a perfect knowledge of it. We'll never find out.

Alongside one of the highways that in the name of the automobile have displaced people, two boys train them-

selves in the ancestral rite of the bullfight, a bloody esca
from misery. Under the protective gaze of the Virgin o
Guadalupe, in whom all beliefs and bloods commingle, a
young man explores the modernity of an electronic game
The enormous old radio looks outdated, but not as much as
the solemn bust of a former president.

They never gave Zapata the chance to become dissipated
by power. His semblance observes, warns, proclaims from a
wall spared from demolition. A thousand-year-old man car
ries the symbols of two enemy religions, which on his body
and across Mexico have united, though they remain unrec
onciled. The cornerstone of a colonial building is the head
of a serpent — symbol of the earth and of endless renewa
— discovered in Templo Mayor. In the background loom the
horrible buildings that, for the sake of profit, have replaced
the grand edifices of the past. And in the foreground, a gir
who could have been standing in that very place for the las
three hundred years, sells her sad wares. The stone serpen
rhymes with the living, hissing one held by a young mar
n a Texas "gimme" cap. It's as if a mockery were being made
of our efforts in recent years to become Mex-Texans instead
of mestizos.

Two children embrace in solidarity on the dirt road of their
neighborhood. Yesterday's car in the "last city" is another
warning of how quickly things change. The diablitos that
entangle the circuit boxes show to what degree our surviva
has become entangled with the illicit: we steal electricity
the way we steal life.

Inside a house, a television set has become the new altar
Where figurines of the saints once stood now ghosts shim
mer on the screen. How different the sexy aerobics instruc
tors and diet-fad spokespersons on TV are from the flesh

and-blood prostitutes who migrate from the countryside to suffer in our barrios! And with what respect has Ortiz Monasterio's camera captured them. Television is a lot of things, but above all it's a selling machine: it sells records, t-shirts, and detergents, as well as the idea that violence pays or at least compensates us, for a precarious moment, for all our humiliations and failures.

The pathos of a blind beggar becomes an icon of strange beauty and homage to the dignity of all human beings. Dogs — inescapable companions of misery — slink through Ortiz Monasterio's photographs, embodying resistance and endurance. The valley's unending ecological disasters are symbolized by a dead dog's head. The dead dog is an unwitting reminder of Tolstoy's apocryphal Gospel: Jesus makes his disciples see the perfection and beauty of the dog's teeth where they have only seen a carcass bloated to the bursting point. For those who can see the essence of things, not even carrion is repulsive.

Ortiz Monsterio closes his book with images of armed youths and dramatic personifications of Christ, including the Christ of Iztapalapa, who, each Good Friday for nearly the last 150 years, has been the center of a reenactment of the Passion at the summit of the Cerro de la Estrella. Each time there is a different person in the costume — yet somehow he is always the same. Another is the Christ of a church with no name. Blistered, sorrowful, with blood oozing from wounds caused by spears, thorns, nails, and whippings, he exudes all the power of defenselessness and all the persistence of faith.

Ortiz Monasterio has not sought to accumulate images of the pretty, picturesque, plastic, "modern," or "advanced"

Mexico. Instead, he has given us a mirror in which we can see ourselves as we'd least wish to be seen. We want to tell him we're not really like this, that this is not our likeness, that he should have made us a little more presentable. But history has proven Ortiz Monasterio to be right, and now we know that this is what we are, like it or not.

What remains of us? All and nothing: the tree of hope on the last page, outlined against the mountains of the wounded valley and the last reaches of the dying city. This tree has withstood every human and inhuman catastrophe, and there it remains, turning green once again.

José Emilio Pacheco, 1995

(translated by Joseph Skinner)

This first edition of Pablo Ortiz Monasterio's *The Last City* is limited to 3,000 casebound copies. The text is copyright José Emilio Pacheco, 1995. The photographs are copyright Pablo Ortiz Monasterio, 1995.

The photographs are reproduced using the sheet-fed gravure method on uncoated Japanese paper. The text is set by Eleanor Caponigro in Myriad with Didot. Edited and designed by Jack Woody and Pablo Ortiz Monasterio. Printed by Nissha Printing Company, Kyoto, Japan for:

TWIN PALMS
PUBLISHERS
401 Paseo de Peralta
Santa Fe
New Mexico 87501
505 988 5717

ISBN 0-944092-32-2

1995

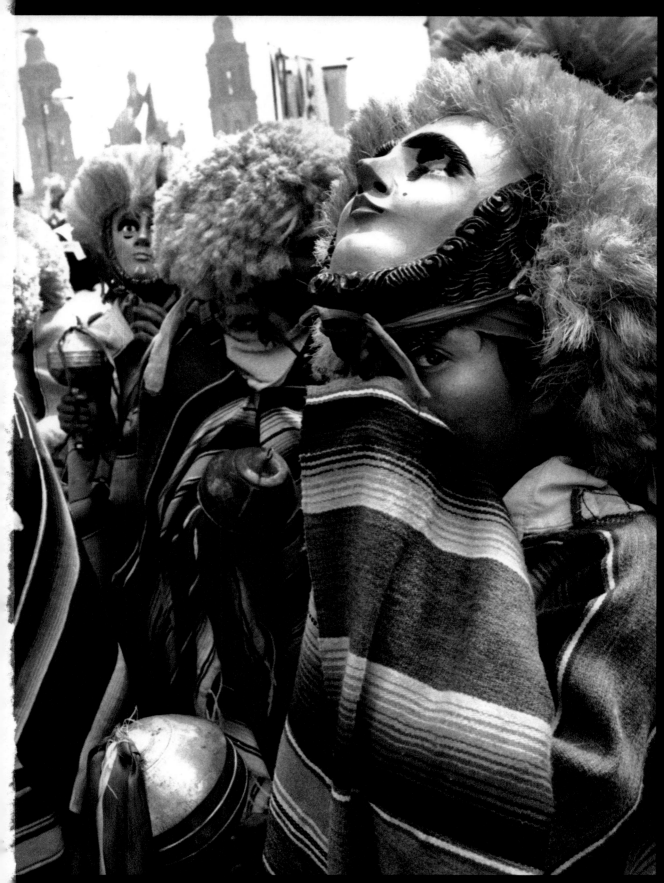

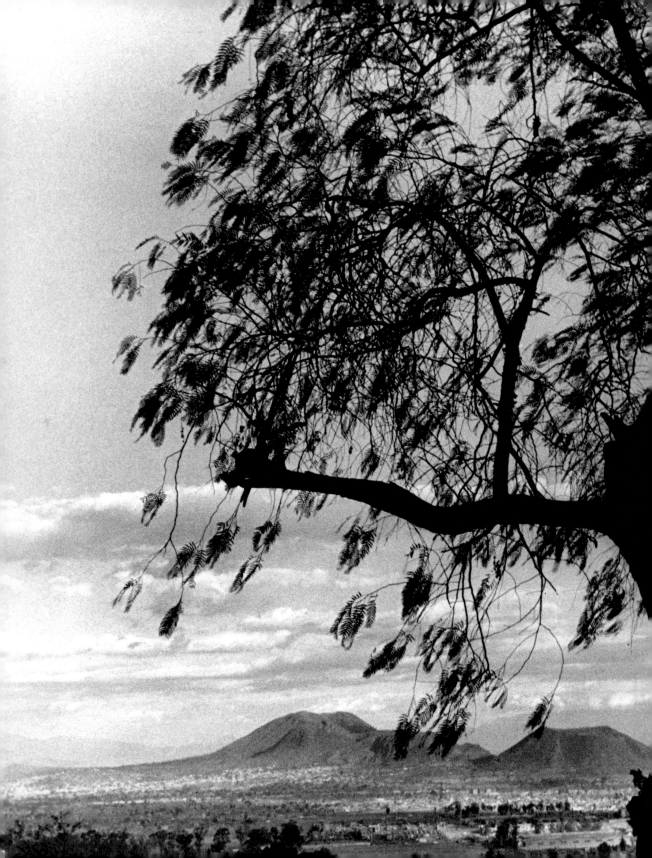